Cuba: After the Revolution

WRITTEN AND PHOTOGRAPHED BY **BERNARD WOLF**

DUTTON CHILDREN'S BOOKS ★ NEW YORK

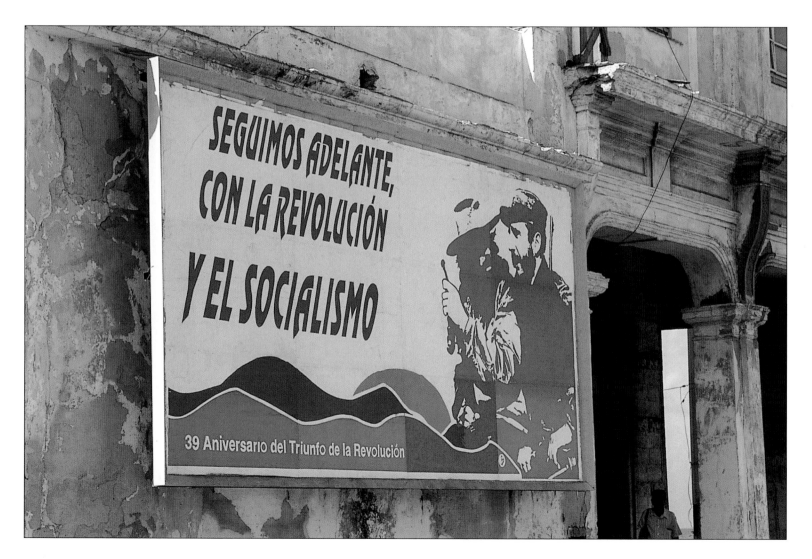

This book is dedicated to the people of Cuba.
May your future brighten and your finest aspirations be realized.

ACKNOWLEDGMENTS

I wish to thank the following people for their gracious assistance and many kindnesses
during my stay in Cuba: Alicia Leal, Juan and Ana Moreira, Alicia Alonso, Enrique, Luis,
Nella, Raymondo, and Beatriz. In New York City: Once again, I must express my pleasure and
gratitude to Laurin Lucaire, Dutton Children's Books, for yet another outstanding design job!

CIP Data is available.
Published in the United States 1999 by Dutton Children's Books,
a division of Penguin Putnam Books for Young Readers
345 Hudson Street, New York, New York 10014
http://www.penguinputnam.com/yreaders/index.htm
Designed by Laurin Lucaire
Printed in Hong Kong
First Edition
1 2 3 4 5 6 7 8 9 10
ISBN 0-525-46058-6

INTRODUCTION

Only ninety miles of ocean separate Havana, Cuba's capital city, from the United States, the world's sole superpower and Cuba's only powerful political adversary. American involvement with Cuba stretches from the eighteenth century to the present. Shortly after 1783, Cuba, then a Spanish colony, became the major supplier of sugar to the United States.

In Cuba, as in most of Spanish America, there existed two classes of people. At the top were the extremely rich, a relatively small group of families who owned and profited from their vast sugar and tobacco plantations. To work their lands, they imported tens of thousands of slaves from Africa. The slaves, along with most of Cuba's native population, lived in crushing poverty, ignorance, and fear.

By 1825, inspired by the South American liberator Simón Bolívar, Mexico and other Latin American countries had won independence from Spain. Bolívar wanted to free Cuba as well, but he was warned off by the U.S. government. America's commerce with the island under Spanish rule had become too profitable to risk upsetting.

In the mid-nineteenth century, the United States twice offered to purchase Cuba from Spain. The offer was twice rejected. But through poor management in the following decades, many Spanish landowners found themselves facing bankruptcy. American investors quickly swooped in and picked up huge plantations and other businesses cheaply.

This was also a time of great social protest in Cuba. Two long and bloody revolts for independence from Spain were ruthlessly put down. America was silent. The United States was biding its time, waiting for an excuse to seize Cuba for itself.

In January of 1898, Washington sent the U.S. battleship *Maine* to Havana "to protect U.S. citizens in Cuba from Spanish atrocities." The ship mysteriously blew up, killing 266 American sailors. Spain protested that the explosion was deliberately set off by U.S. naval officers in order to provoke an incident. But the United States declared war on Spain and sent a large naval and land force to Cuba. Less than three months later, the Spanish-American War ended with the surrender of Spain.

Cuba was granted "self-determination" but was placed under U.S. military occupation, with the U.S. given the right to intervene in Cuba's internal affairs "whenever it was warranted." At first, Washington installed ineffective and sometimes corrupt governors to rule the island. Later, it supported corrupt and brutal dictators.

Life for most Cubans was little better than what they had experienced under Spanish rule. Poverty, ignorance, and fear continued unchecked, as did racial prejudice. Afro-Cubans could not walk where their white countrymen walked. Only the wealthy could afford education and medical care. Thousands of Cuban children died of malnutrition and disease.

By the 1920s, Americans owned two-thirds of Cuba's farmlands and most of its valuable resources. Labor was cheap and profits soared. American tourists flocked to Havana, attracted by its posh gambling casinos, nightlife, and Prohibition-free liquor.

In the Great Depression of the 1930s, Cuba's economy collapsed. Millions of Cubans became unemployed and desperate. In the midst of this crisis, Cuba acquired a new dictator. Fulgencio Batista ruled Cuba through suppression and terror. One of his favorite methods of "disappearing" his detractors was to have them dropped from aircraft into the shark-infested waters outside Havana. With the arrival of World War II, prices for Cuban sugar and raw materials soared again. Batista quickly declared himself an enemy of America's enemies. In return, he was left free to rule Cuba as he saw fit.

But the flame of Cuban rebellion had not been entirely extinguished. In the early 1950s, a group of revolutionaries formed secretly in Havana. Among them was a young lawyer named Fidel Castro. The group's purpose was to overthrow Batista's regime and create a Cuban republic free from all foreign intervention. Gradually, the group attracted popular support for its cause, and after years of bitter guerrilla warfare, its goal was achieved. In January of 1959, revolutionary forces took control of Havana and sought to bring Batista to justice. But they were too late. Only days earlier, the dictator had fled from Cuba, taking with him forty million dollars of national funds.

The new revolutionary government appointed Fidel Castro premier of Cuba and launched a series of sweeping social and economic reforms. Racial discrimination was abolished. Free public education and medical

care for all citizens were established. Rents and electricity rates were sharply cut.

In April of 1959, Castro flew to Washington. He hoped to meet quietly with President Dwight D. Eisenhower to establish a new relationship of mutual respect and cooperation between Cuba and the U.S. Instead, Castro was received by Vice President Richard M. Nixon, who lectured him on the follies of his new reforms for Cuba. He ended by calling Castro a Communist, an accusation Castro denied. It was a fateful interview. Nixon informed Eisenhower that, in his view, Cuba's new regime posed a serious threat to America's interests and national security. He urged that steps be taken against this threat.

In Cuba, a bitter Castro and his government began a long-range program of land reform. Gradually, the island's largest agricultural estates and essential businesses, owned mostly by American corporations, were nationalized. Washington was furious. Secretly, C.I.A.-backed guerrillas were organized in Cuba to create as much havoc as possible.

Meanwhile, adding to Cuba's economic problems, thousands of professionals and technicians who had supported the Batista regime were leaving Cuba for exile in Miami, Florida. Facing crisis, Cuba turned to the Soviet Union for assistance. The Soviets responded with trained technicians and a favorable trade agreement.

In March of 1960, President Eisenhower authorized the C.I.A. to train and arm a counterrevolutionary force to overthrow the Castro government. Six weeks later, Cuba established formal diplomatic relations with the Soviets, who began to send large shipments of petroleum and other products to Cuba. Eisenhower cut Cuba's sugar export quota to the U.S. The U.S.S.R. offered to purchase any sugar America refused to buy.

Each effort by the U.S. to damage Cuba was met with a countermove by the Cubans—backed by the Soviets, who, to their own surprise, had suddenly found their toes on the doorstep of their archrival, America.

In January of 1961, Washington severed all diplomatic relations with Cuba. In April, America's new president, John F. Kennedy, tacitly approved the invasion of Cuba at the Bay of Pigs by a force of 1,400 Cuban émigrés, trained by the C.I.A. But Kennedy refused direct U.S. military involvement. As a result, the invasion was dealt a humiliating defeat. Two days later, Castro declared Cuba a Communist republic. In June, Washington imposed a total trade embargo against Cuba, which affects the lives of the Cuban people to this day. The Soviet Union sidestepped this crisis by sending massive shipments of everything the island needed to keep its economy afloat.

American U-2 spy planes continuously flew over Cuba. In 1962, one of these aircraft returned with photographs revealing that the Soviets were secretly constructing launch sites for intermediate-range ballistic missiles capable of reaching targets anywhere in the U.S. President Kennedy warned Moscow that unless its missiles were removed, the U.S. government would take action to remove them. In October, in the culmination of what is now known as the Cuban missile crisis, Kennedy ordered American warships to stop, search, and prevent all Soviet vessels carrying missiles from reaching Cuba "by whatever means necessary." Americans waited with horror for the anticipated nuclear destruction of their world. But Moscow backed down. After receiving personal assurance from Kennedy that the U.S. would make no further attempts to invade Cuba, Premier Nikita Khrushchev directed all Soviet launch sites on the island to be dismantled and all missiles returned to the U.S.S.R.

With the continued aid from the Soviets, Cuba's economy remained stable for thirty years. But with the collapse of the Soviet Union in 1991, that aid stopped, and Cuba plunged into a crisis from which it has not yet recovered. The Russians had quietly departed from America's doorstep, but America's trade embargo against Cuba has not gone away. ★

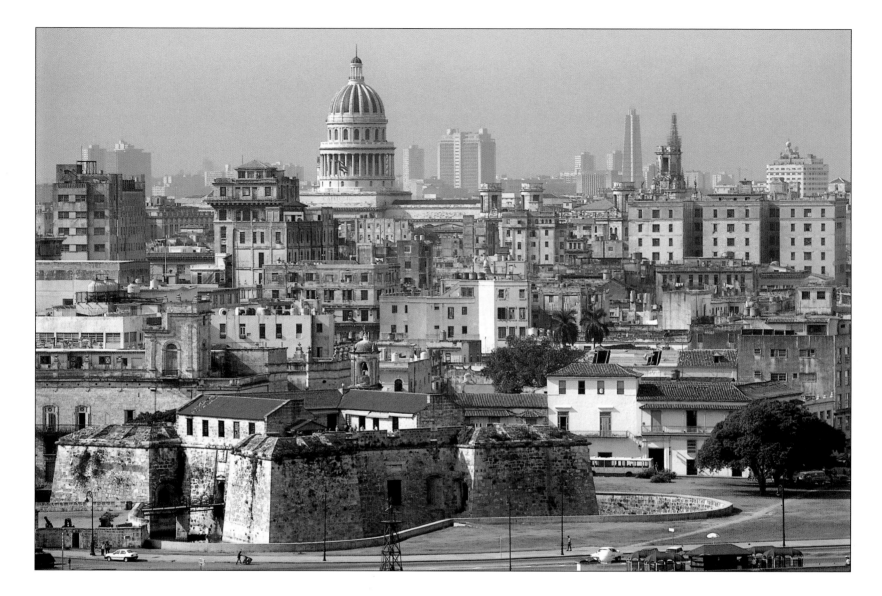

avana sprawls along Cuba's northwestern coast. In 1564, it was established as the most important seaport in Spain's vast New World empire. Each year for the next two centuries, Spanish galleons laden with treasure plundered from Mexico and the southern Americas gathered here, formed into a great flotilla, and sailed proudly across the Atlantic to Spain. Havana became Spain's most valuable center for the slave trade until 1865, and for shipping and commerce until the Spanish-American War in 1898.

Today, with its population of nearly two and a half million inhabitants, Havana has expanded greatly.

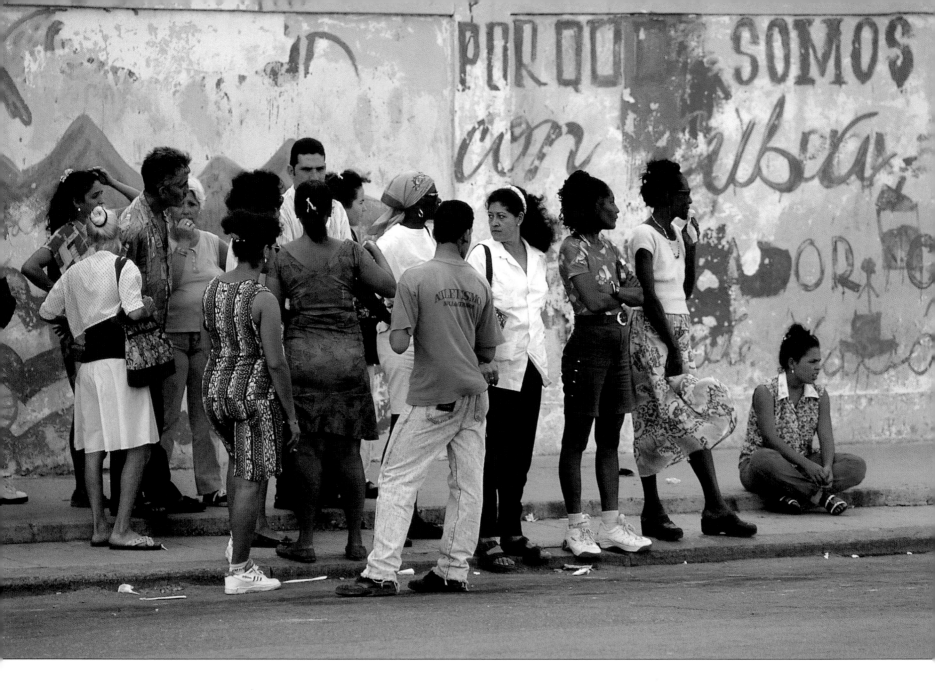

It's a huge city, divided into fifteen municipalities, and getting from one part of it to another is difficult. Because of frequent shortages of fuel and spare parts, waiting in long lines for a bus is an everyday test of endurance.

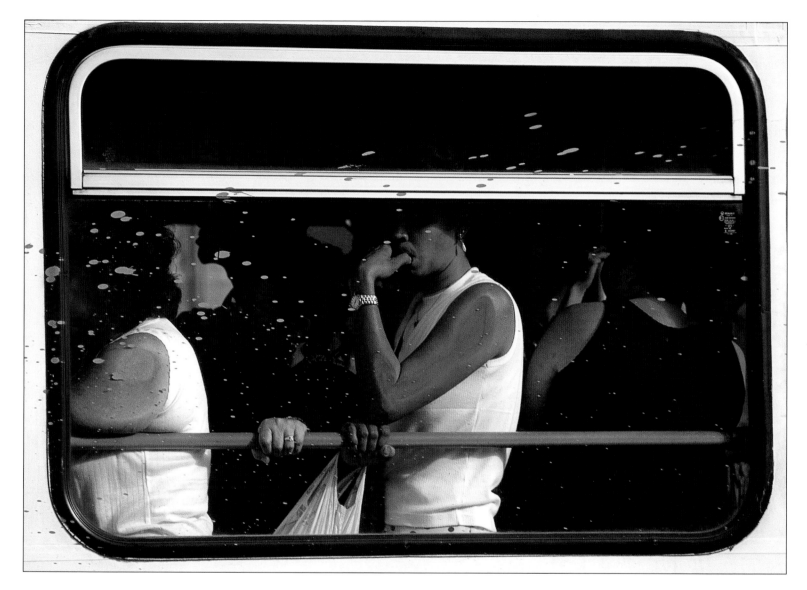

But finally, here comes a *camello* ("camel"), a nickname for the largest type of Cuban bus. A truck hauling two long, humpbacked passenger compartments grinds to a shuddering halt. The doors hiss

open and a few passengers get off—but only a few can get on. The "camel" roars off, its passengers packed tightly together. There's still a long line of people waiting for the next bus.

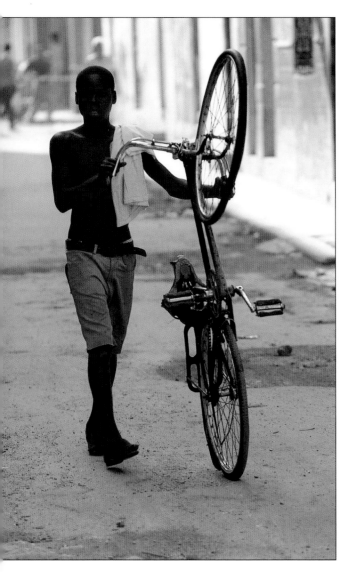

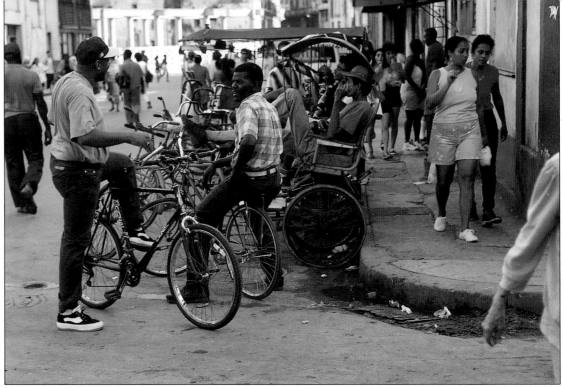

For most of Havana's citizens, it is the humble bicycle that provides transportation. And for those who would rather not pedal, there are even bicycle taxis, available at reasonable rates.

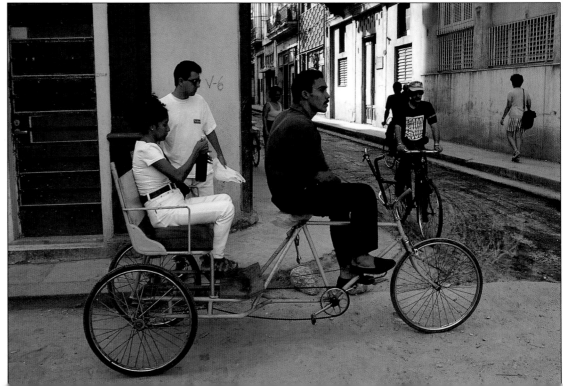

Owning an automobile is a luxury few Cubans enjoy. Those in use are usually handed down from one generation to the next. In Cuba, old cars never die; their parts are salvaged for use on other cars. As a result, strange vehicles may be seen on the streets of Havana. But what factory produced this one? Well, it's got four wheels, a valid license plate, and it moves when it has fuel. What else matters?

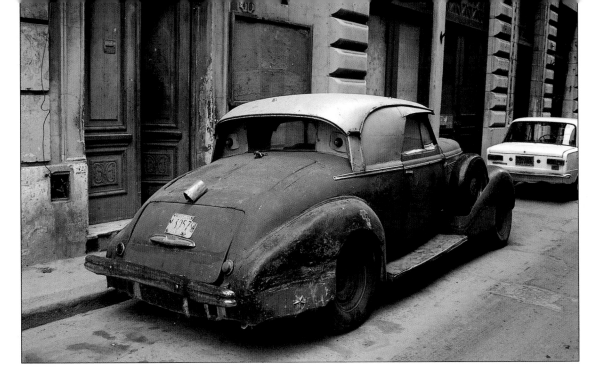

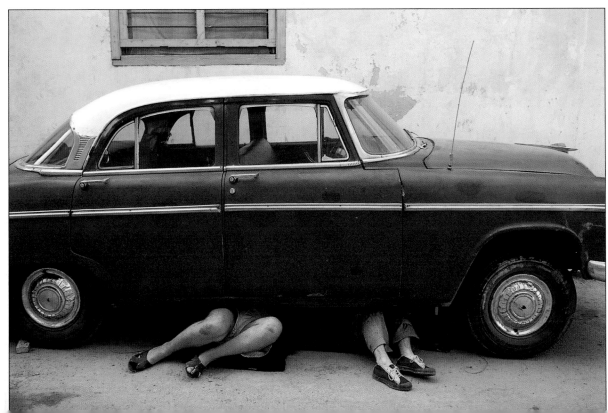

Cubans are wizards at making repairs. They have to be. New parts are impossible to obtain. People who are lucky enough to own even the oldest cars treat them with tender loving care.

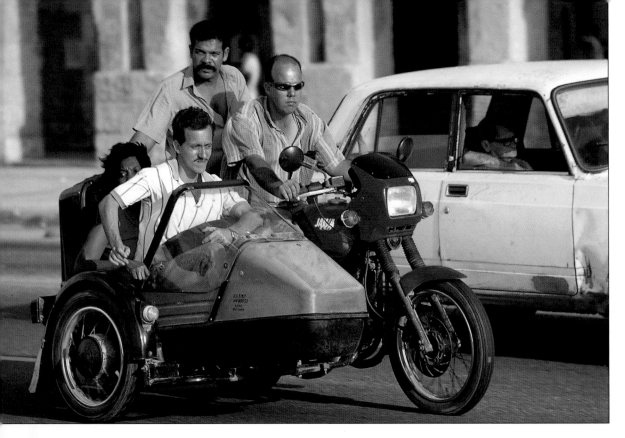

Whatever their vehicle of choice, Cubans certainly are inventive. Clearly, they are a people who prefer wheels to walking!

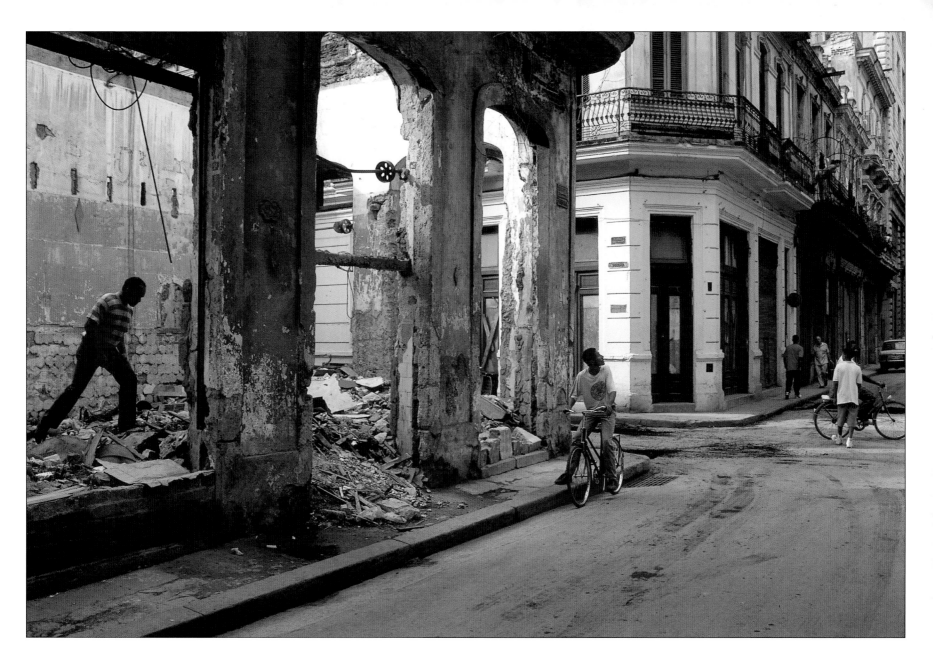

Old Havana is crumbling. In fact, much of its priceless heritage of Spanish colonial mansions, public buildings, and monuments is falling down. Each month, fine old buildings collapse, often killing some of the inhabitants—and very little can be done about it.

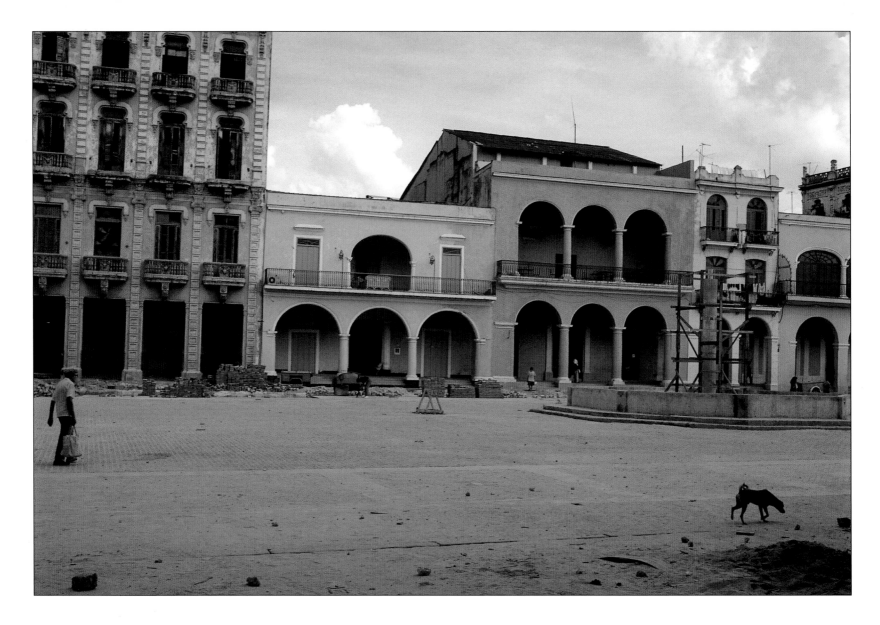

While there are attempts to restore a few prominent landmarks, there simply isn't enough money to undertake the massive repair and restoration required for the old section of the city. Here at La Plaza Vieja, one of the first public squares constructed by the Spaniards in the sixteenth century, a meticulous renovation has been under way for ten years. But progress has been slow, because the government is forced to spend its available funds on more urgent needs such as food, petroleum, and industrial equipment.

Nor is there enough money for new housing development. Most people live, rent-free, in apartments or small houses that they share with or have inherited from their parents. But for young newlyweds who want the privacy of separate homes, there are few solutions.

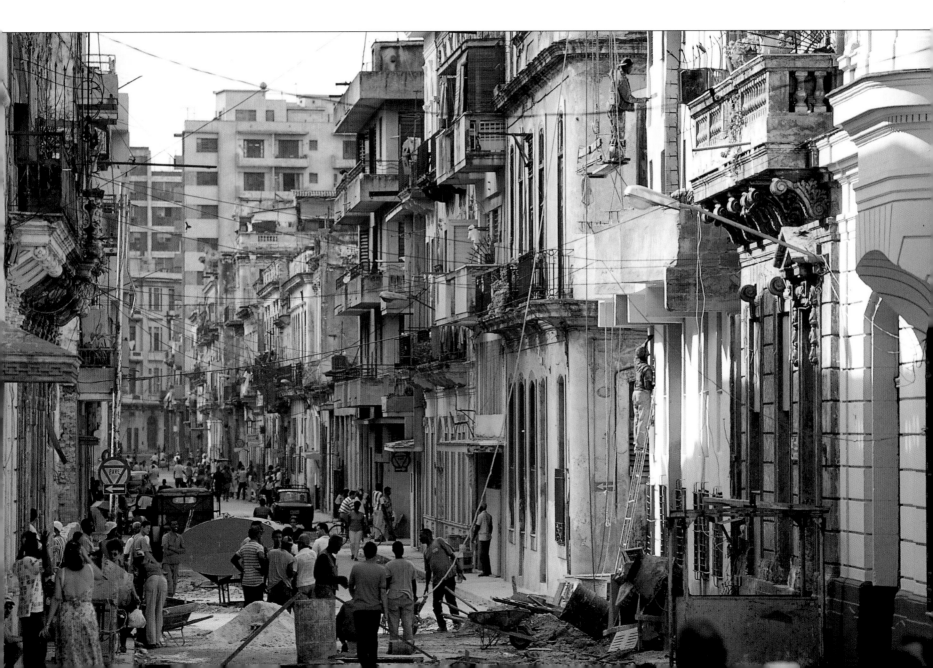

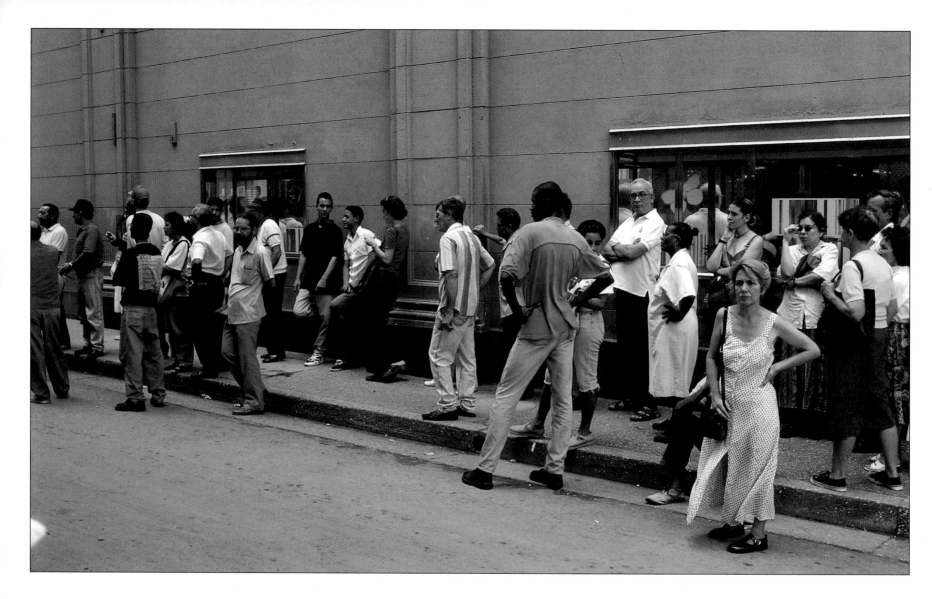

Waiting in long lines for the simplest necessities (which in other lands are taken for granted) has become a way of life for Cubans.

Today there are shortages of practically everything. And yet these people manage to endure without losing pride and dignity—or their enjoyment of simple pleasures.

Ever optimistic, Cubans are remarkably friendly, courteous, and helpful, not only to one another but to total strangers— even to the rare North American visitor. Their generosity is touching. It is common for neighbors to give of their own scarce food to feed the child of a family that has none.

In all of Latin America, there is probably no safer city than Havana. Drug abuse hardly exists. Women may walk through the streets of the city at three in the morning without fear of being molested. Crimes of violence are infrequent. Murders are extremely rare; the punishment is swift and final—death by firing squad.

Habaneros seldom bathe in warm water—not because they wouldn't prefer to, but because most homes don't have hot-water systems. Yet they, and the clothing they wear, are sparklingly clean. And how they love to talk—and talk! Just try reaching someone on the telephone!

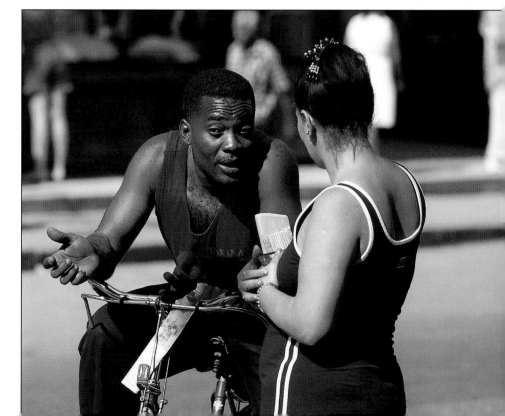

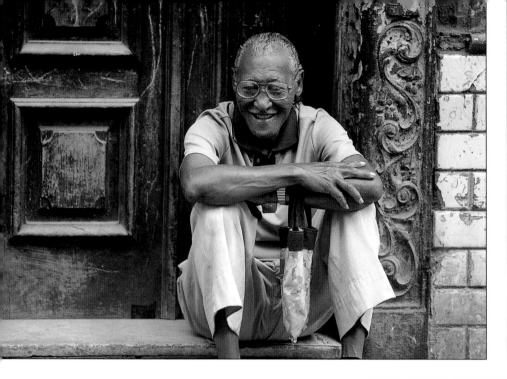

Over the centuries, Cubans have evolved into a rich, interracial mix. These warm, intelligent, and handsome people have a deep love of their homeland that has never faltered.

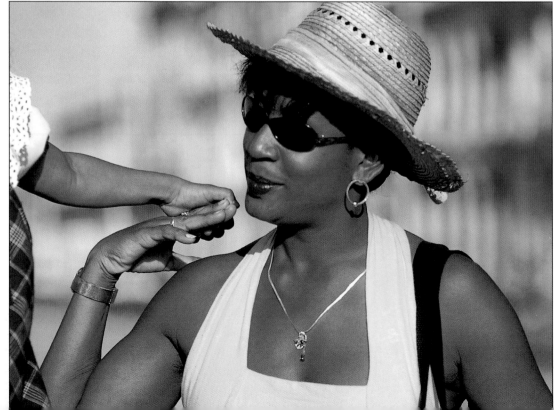

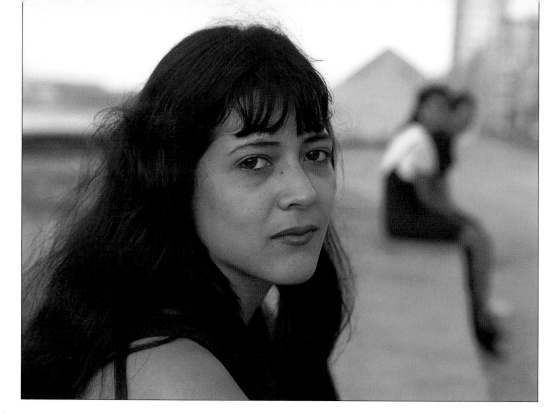
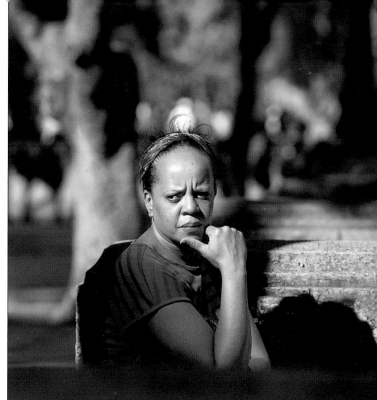
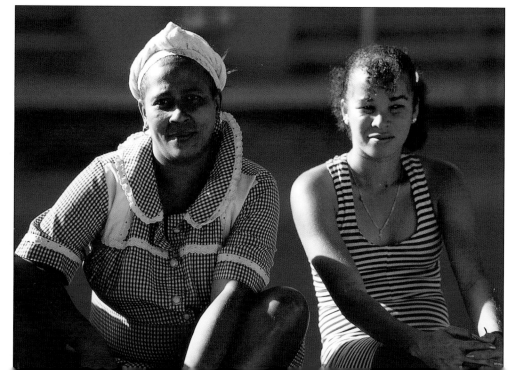
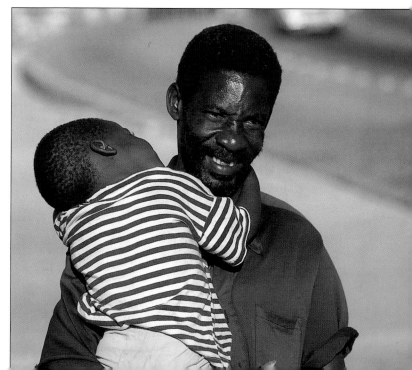

While true affluence is hard to find in Havana, its citizens enjoy good health care, clean air, an atmosphere of tolerance, and the freedom to express their intensely romantic natures.

At the Palace of Matrimony, business is booming! Inside, loving young couples await their turn to exchange vows. Outside, new brides and grooms approach festively adorned old cars that will whisk them away to lives of togetherness.

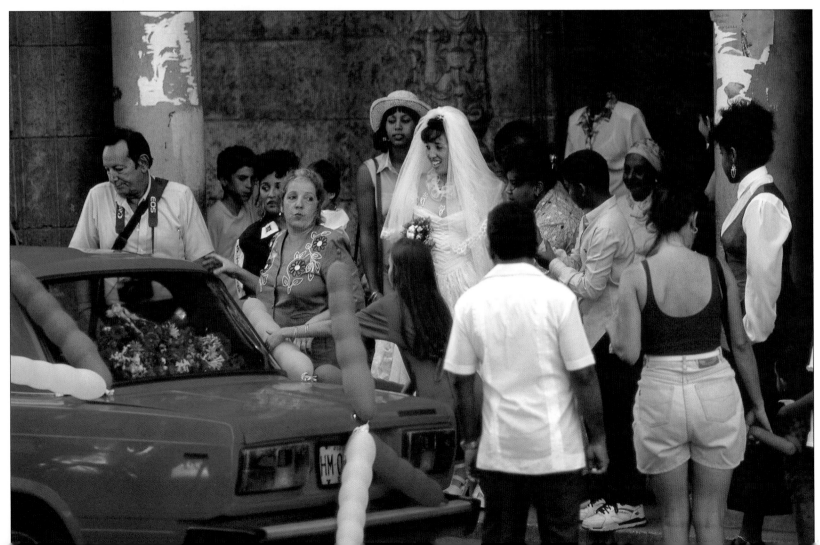

But when all the celebrating ends, these newlyweds will be faced with tough realities. Even with a university education, a young Cuban husband begins his career earning minimum wages. Even when a wife works as well, their combined income is often inadequate to support a family when children arrive. Some marriages do not survive such stress.

In Cuba, all workers are considered employees of the government and are paid fixed monthly salaries based on the jobs they are qualified for. For example, a street cleaner may earn 150 pesos; clerks, technicians, and schoolteachers, 200 to 250 pesos. The maximum allowed salaries are paid to government officials, university professors, airline pilots, and doctors: 400 pesos. Most Cubans earn about 200 pesos per month, which equals ten dollars in U.S. currency. This may not seem like much, but at Cuban markets, a peso can go a long way. To help stretch the peso's value, every citizen is issued a monthly ration card that allows the purchase of basic essentials for pennies—when they are available. In theory, these include a few pounds of rice, sugar, dried beans, potatoes, lettuce, tomatoes, bananas, and six eggs per month; four ounces of coffee every fifteen days; one half-pound of chicken, eight ounces of cooking oil, and one bar of soap every two or three months. The government distributes only those items that can be produced in Cuba, but some are often in short supply, and even when available are clearly not enough to sustain many families.

Faced with the soaring costs of importing crucial materials from abroad, Cuba was forced to obtain a more stable currency with which to purchase them. At first, all foreign tourists were required to pay for their expenses with American dollars. Then in 1993, Cubans were permitted to own U.S. dollars. At the same time, the government set up many "dollar stores" throughout the island where everything from imported canned foods and Coca-Cola to clothing and shoes could be purchased—but only with American dollars. Now, in all parts of Havana, long lines of people wait to exchange their carefully hoarded Cuban pesos. With the dollars they receive, they can purchase more cooking oil and soap. Some

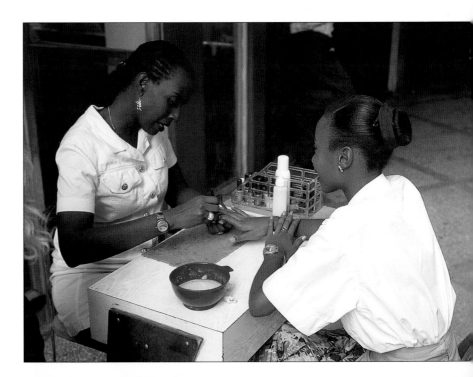

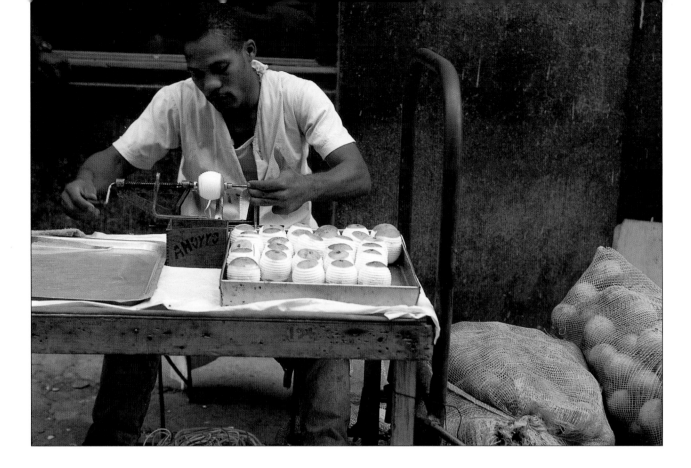

splurge on a small packet of coffee, a pound of pasta, or the rare treat of a can of tuna. While there is no starvation in Cuba, few people can boast of having full stomachs. Finding ways to get more food is a common preoccupation.

But in an important way, life has improved here. Recently Cubans were allowed to work as freelancers. As a result, thousands of Havana's residents are earning extra money apart from their regular jobs. Those who own cars can work as taxi drivers in the evening. Some doctors use their free time to work as waiters in tourist hotels and restaurants, where they may earn as much as five U.S. dollars a day!

In the busy downtown streets of the city, small tables are set up where all sorts of services and goods are offered for sale. A manicurist practices her art on eager customers. Vendors offer quick snacks such as small sandwiches or peeled oranges.

Is capitalism coming to Cuba? Perhaps not through these efforts. However, Canada, Mexico, Spain, and other nations in Europe, the Americas, and Asia have refused to join the U.S. embargo against Cuba. They have been investing in new business ventures throughout the island. And in the United States, powerful corporate voices are saying, "Enough is enough! Let's not get left out of the action!"

When work is done, Havana's residents needn't go far to escape the city's heat. El Malecón offers cool sea breezes and a cost-free escape from the day's problems. This long esplanade curves for miles along Havana's oceanfront. It's ideal for a leisurely stroll, lively conversation, or a good game of dominoes.

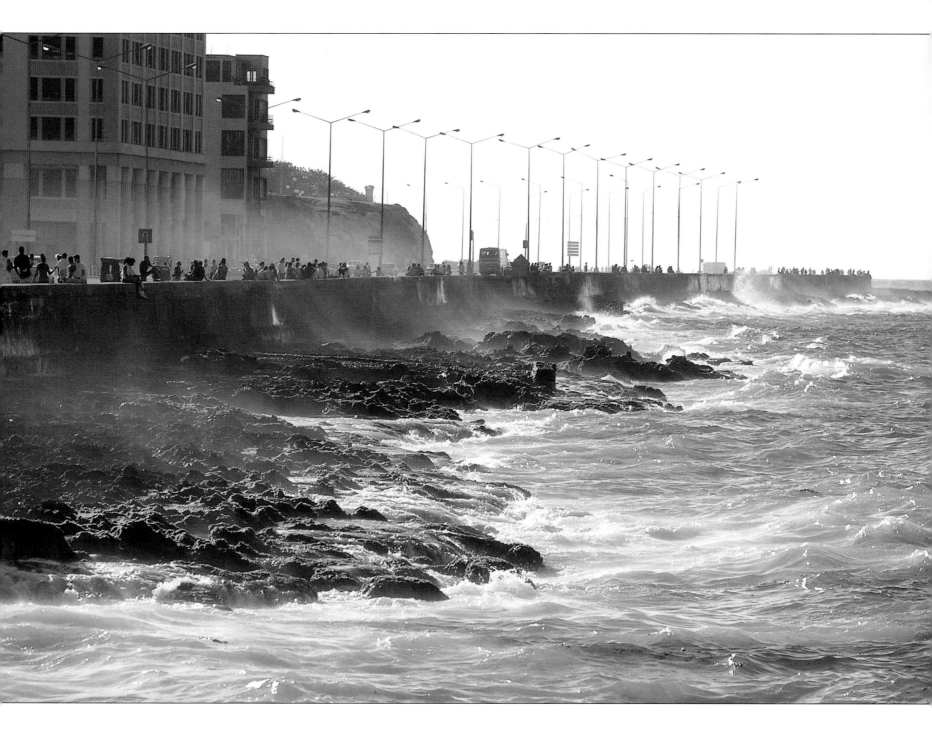

Late afternoons are also the time for children to enjoy the parks of the city. School's out and it's time to play! Hide-and-seek is always popular. So is soccer. Some kids even use filled-in manholes as miniature sandboxes. Some just enjoy a lollipop while hanging out with their pals.

Regardless of the nation's economic problems, it is the children of Cuba who are cherished as the republic's greatest national treasure.

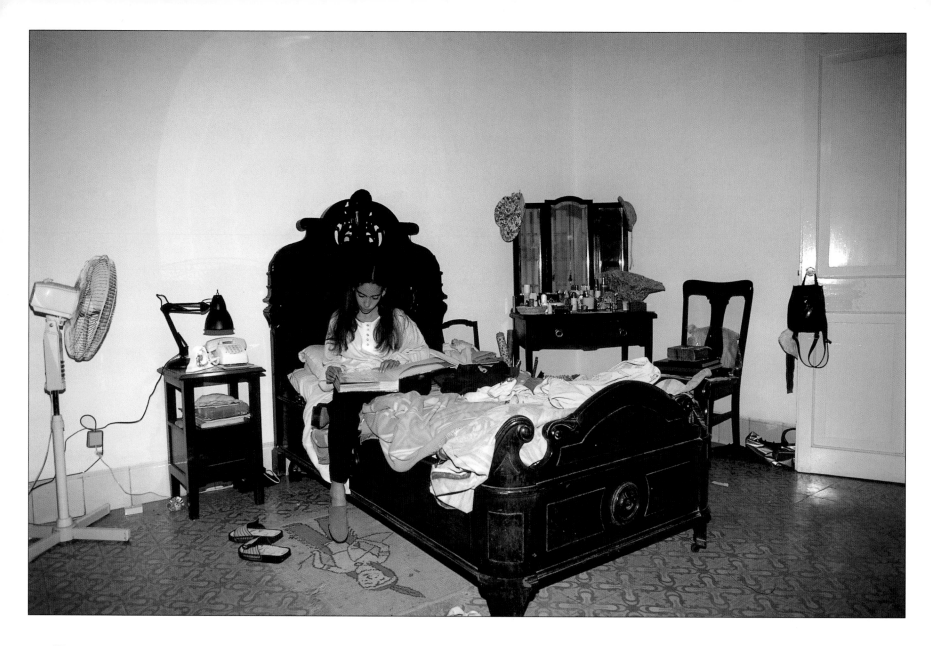

One of these children is Ana Moreira. She is twelve years old and plans to be a ballet dancer.

It's 8:00 A.M. on a school day, and Ana is still calmly lounging in bed! But today is *el día de las profesoras*, when students present gifts to show appreciation for their teachers. There will be no classes. It's a day for fun.

Ana's parents, Juan Moreira and Alicia Leal, are among Cuba's foremost artists.

As her mother combs Ana's hair, Juan tells them his latest joke—with his usual deadpan expression. Then, while Ana and Alicia get dressed, he goes outside to wash the windows of the family's seven-year-old Russian car. It's a grouchy beast at times, but it does still work, and he'd be lost without it.

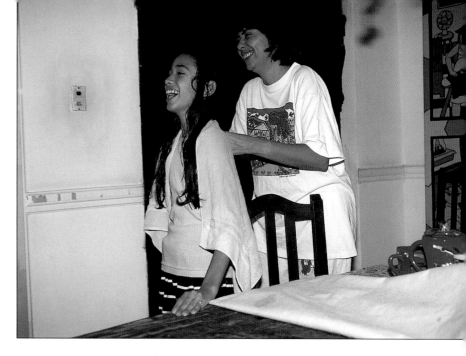

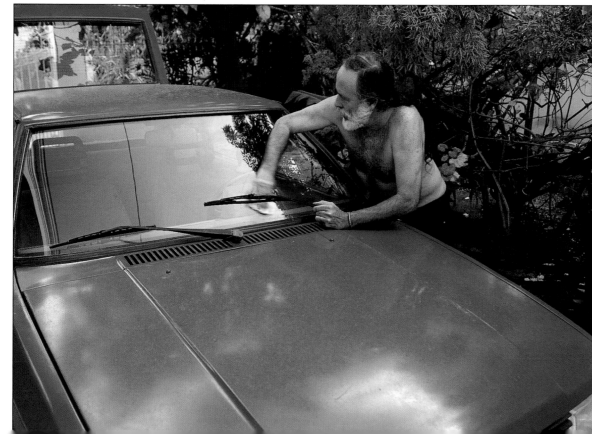

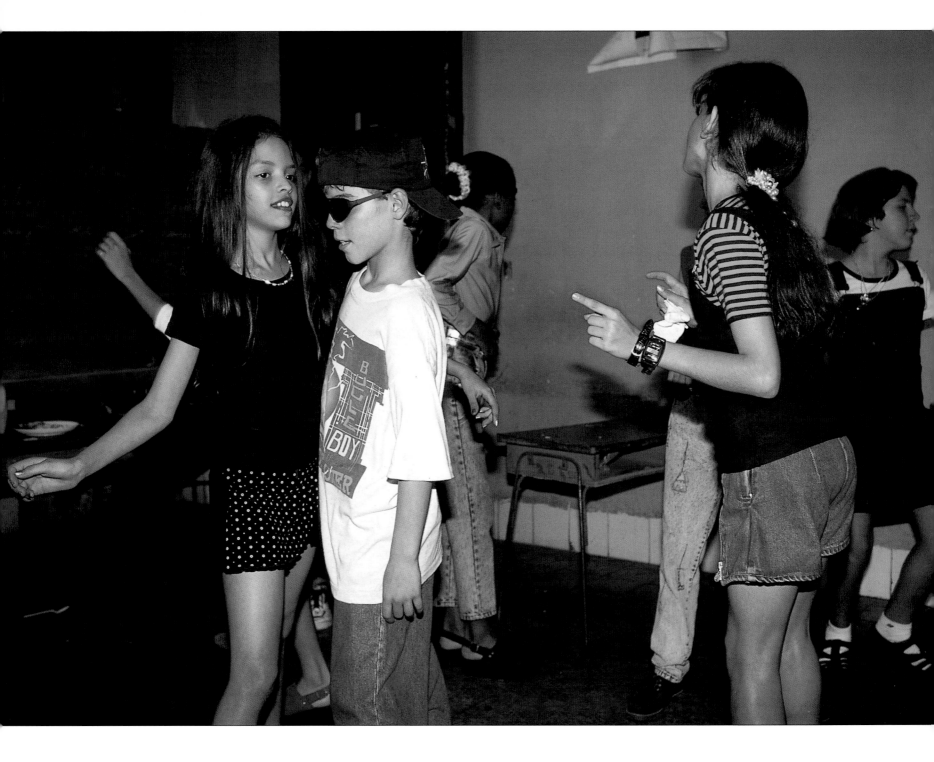

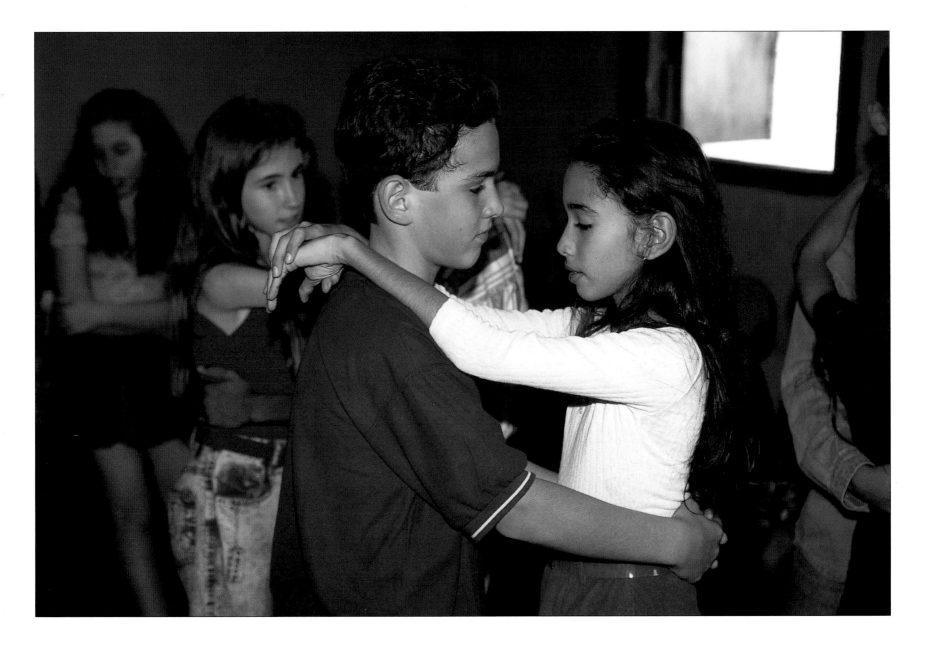

When Ana arrives at her school, the partying has already begun. Pop music blasts from loudspeakers, and everybody is dancing. Gifts are given along with kisses. There's cake and soft drinks for everyone. Juan and Alicia pay their respects to Ana's teachers and chat with other parents. But after half an hour, they leave to visit some artist friends.

Their first stop is the home of Flora Fong. Juan joins Flora in her studio to discuss the progress of a book of her paintings that is being printed in Spain. Then Flora brings in the traditional tiny cups of strong black coffee. After an hour, Alicia and Juan drive to La Habana Vieja to see another friend, who has an art gallery there.

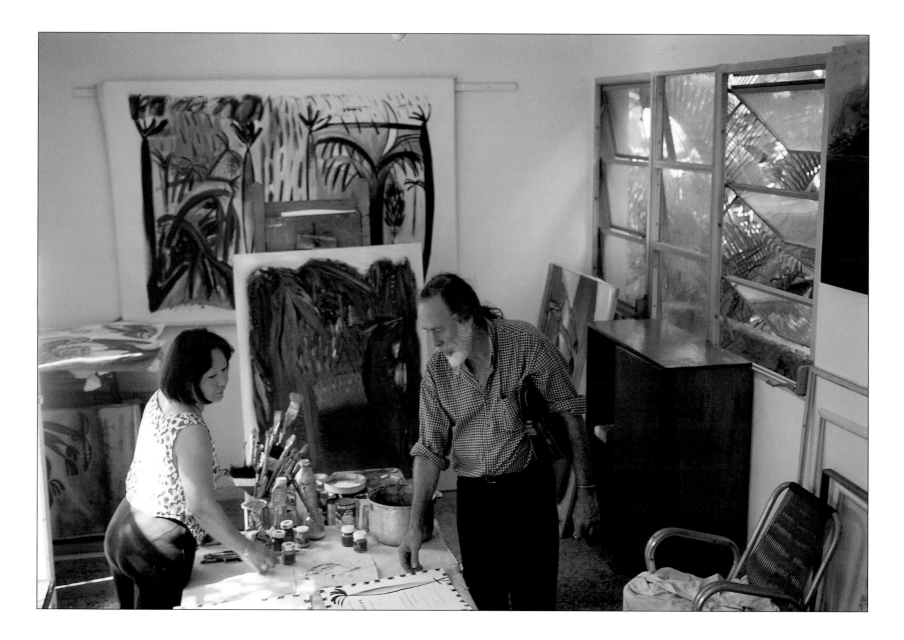

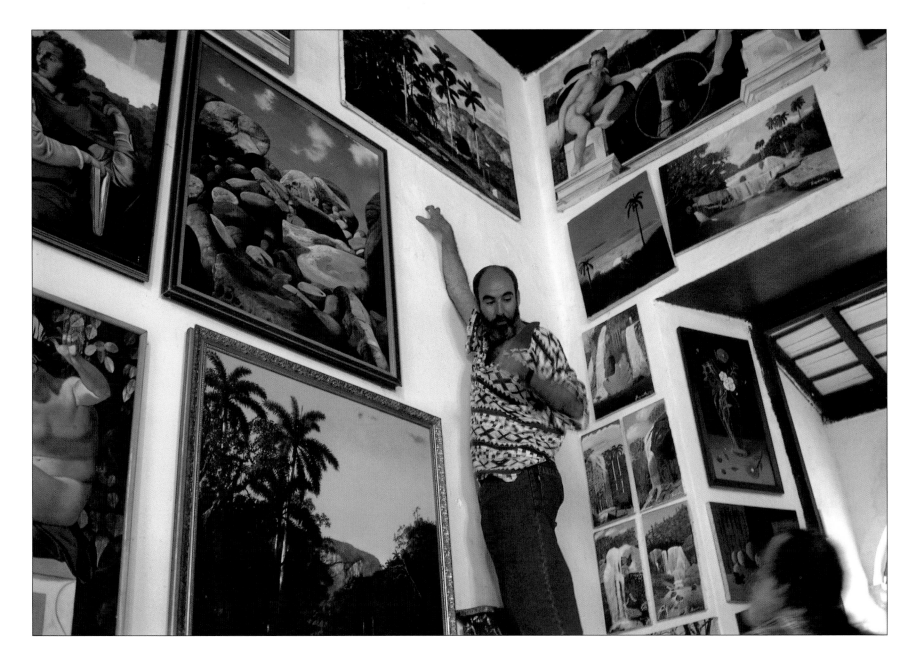

Cuba has a long and rich cultural heritage. Its writers, poets, musicians, and artists are regarded with pride and respect as indispensable contributors to the quality of life in this republic. Since the revolution, artists have been given every possible encouragement and support, freeing them to concentrate their time and energy on their work.

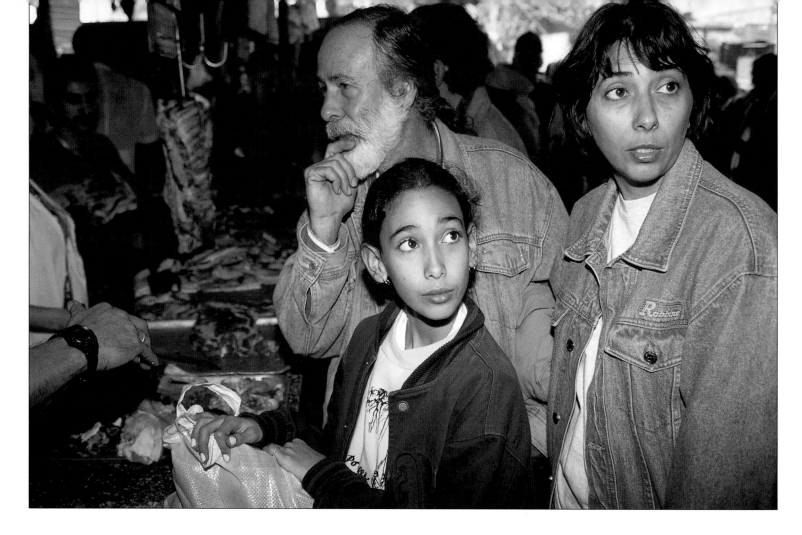

Until the historic visit to Cuba of Pope John Paul II in 1998, Cubans were not encouraged to practice their Catholic faith. Children were not given religious instruction, and Christmas, when celebrated at all, was observed quietly at home. Instead, New Year's Eve is the big national holiday, when families gather for special feasts and the exchange of gifts.

It's the day before New Year's Eve when, after struggling through throngs of other anxious shoppers, Juan and Alicia finally arrive at the market's butcher stall. They are planning to buy a whole suckling pig, but, as usual, Juan has put off their shopping until the last possible moment—and the butcher tells them that the last suckling pigs were sold yesterday! Juan can't believe it. At Alicia's suggestion, he agrees to buy two pork hindquarters instead, and they go on to purchase other foods. On their way home, Ana and Alicia stop at a video-rental store to pick up a few movies for a holiday treat.

After unloading their purchases, Juan drives to where Alicia's parents live and brings them back to the house. Now everyone begins to prepare for tomorrow's feast.

Ana's grandfather, Raul, is an expert at cooking *lechón asado*—roast pig. After Raul trims off the fat, the meat will soak overnight in his special marinade.

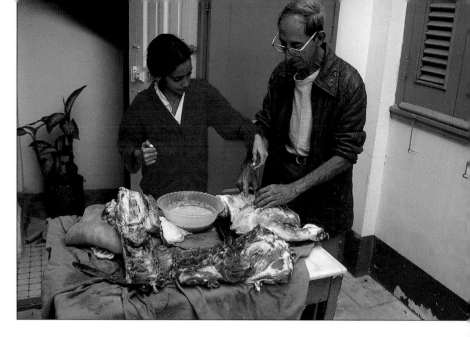

Alicia and her mother, Lidia, wash, dry, and cut up vegetables and salad for tomorrow's meal. Juan is in the backyard, cleaning out the barbecue pit. It hasn't been used since last year.

The next morning, Raul erects an open-wired platform about two feet above a charcoal fire in the barbecue pit. He places the pork on the platform and covers it with a layer of banana leaves. It will take about five hours for the meat to be done.

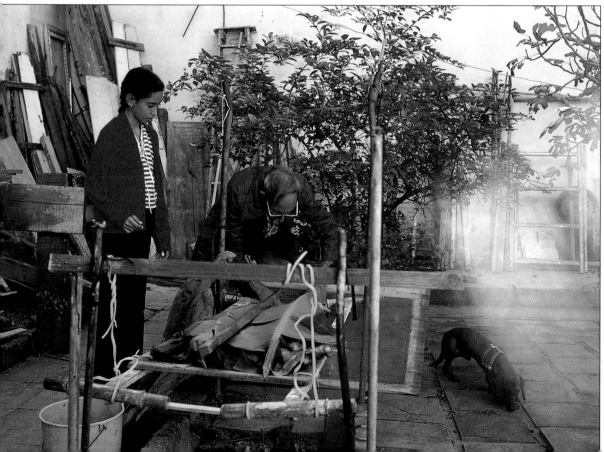

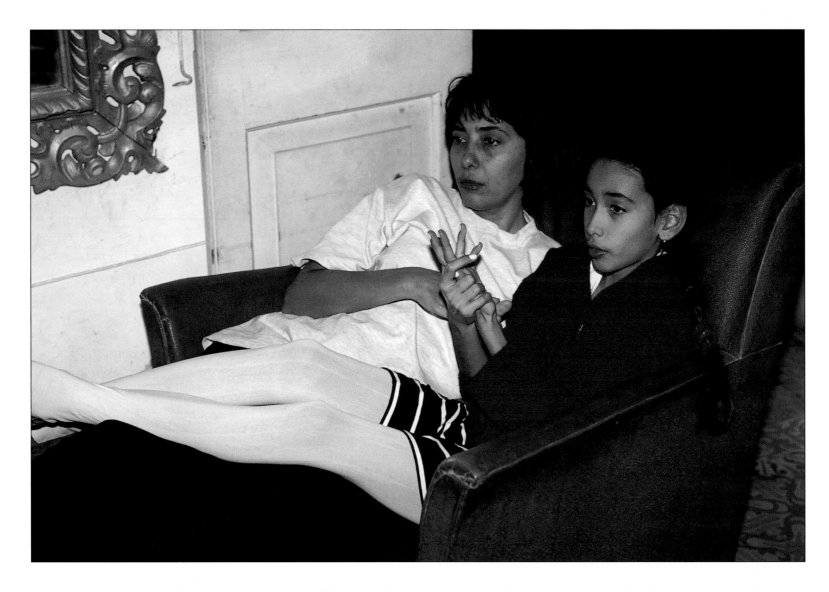

Ana decides it's a good time to watch a video. She doesn't see much TV. In Cuba there are only two television channels, both owned and managed by the government. One channel is heavy on sports, especially baseball, which is very popular in Cuba. The other features political, economic, and soap opera programs as well as news and current events. American movies are the biggest attraction, but they are only shown about three times a week. However, these don't begin until 11:30 P.M.—way past Ana's bedtime.

Alicia's work in the kitchen is finished for the moment. Sharing her daughter's chair, she soon becomes absorbed in the film Ana is watching.

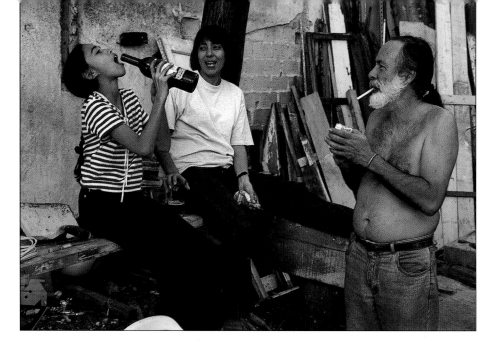

By late afternoon, the aroma of cooking meat has become mouthwatering.

In the backyard, the adults, with obvious relish, are enjoying a bottle of wine. Ana can't understand what all the fuss is about. Before anyone can stop her, she grabs the bottle and takes a small swallow—and immediately spits it out in disgust!

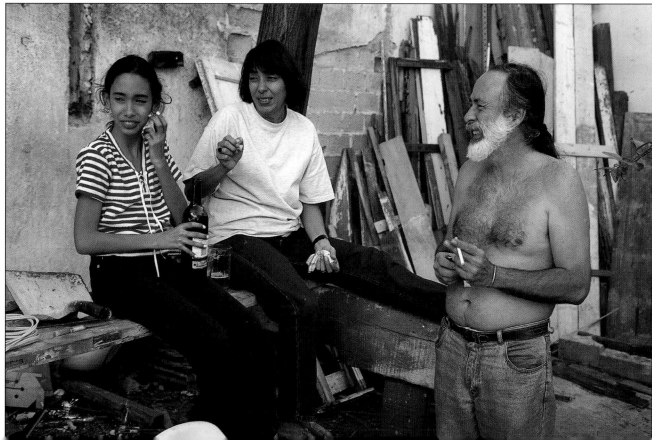

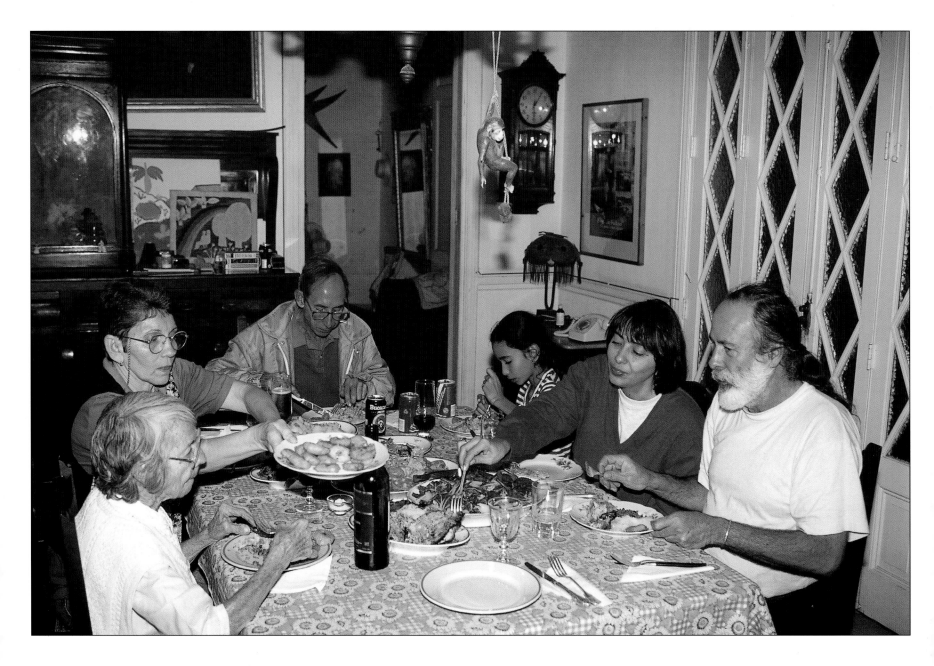

At last, at eight o'clock, the feast is ready to enjoy! Raul's efforts have not been in vain. The roast pork is absolutely delicious!

Juan's eighty-year-old mother, América, is normally a light eater. But tonight even she eats with gusto!

Later that night, everyone moves to the front room of the house to exchange New Year's gifts. Ana gets a new pair of socks and a big alarm clock to replace her broken one. She's going to need it.

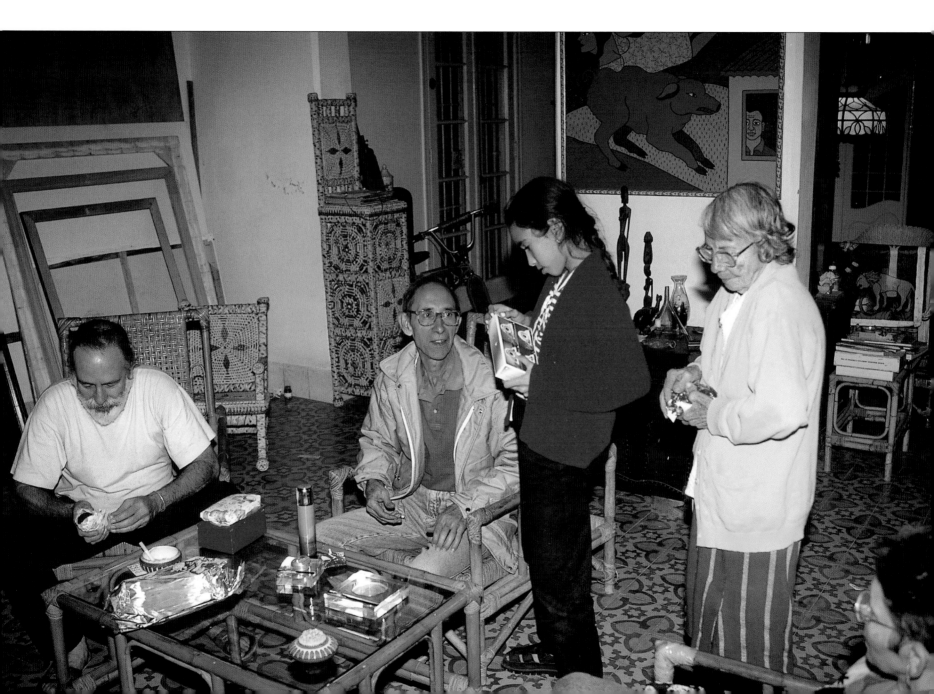

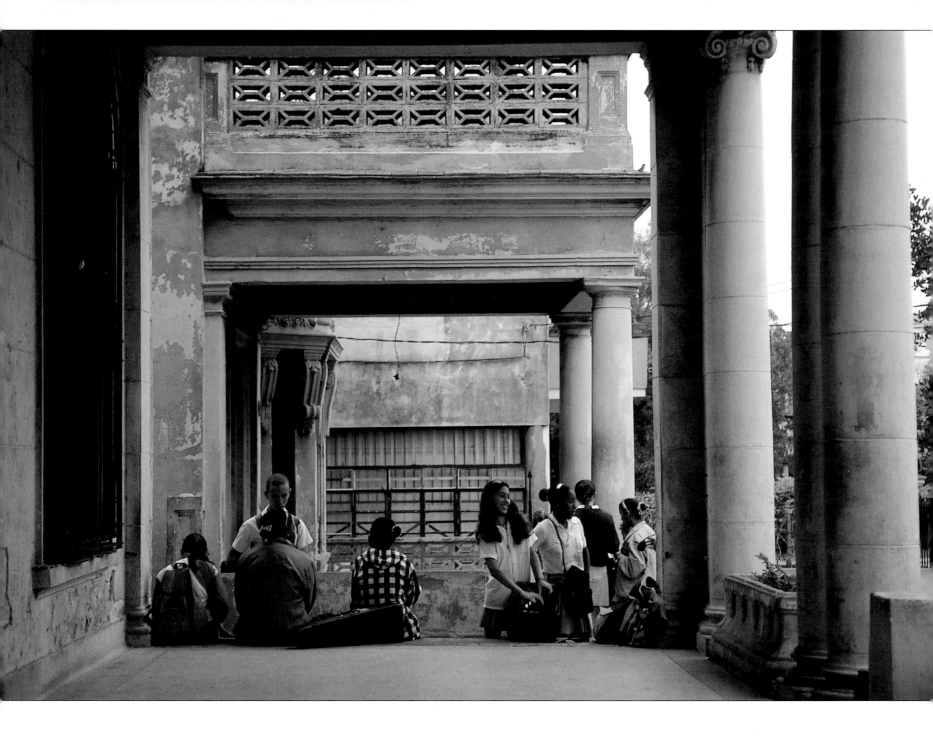

With the holidays behind her, Ana's weekly schedule resumes its normal tough pace. She gets up before 6:00 A.M., bathes, dresses, and grabs a quick breakfast. Then Juan drives her to La Escuela Secondaria de Raul Gómez García, an old private residence that has been converted into a school.

Ana arrives at 7:15 A.M. There's still a little time for her to chat with her friends. Some of the girls show off small gifts of jewelry they received on New Year's Eve.

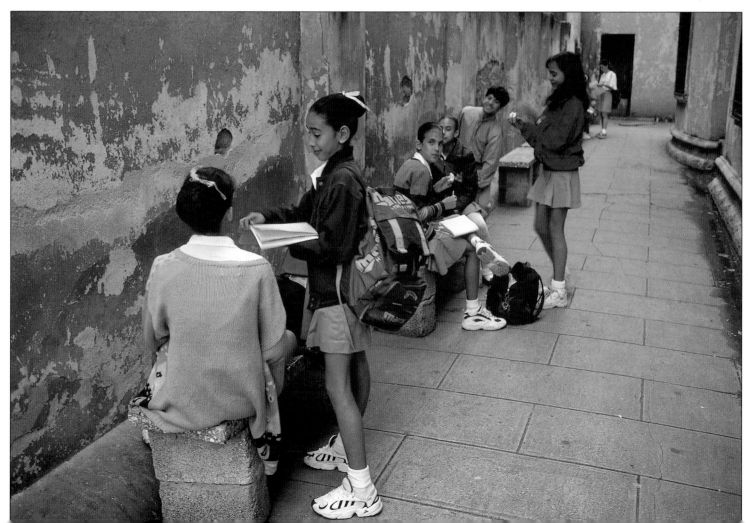

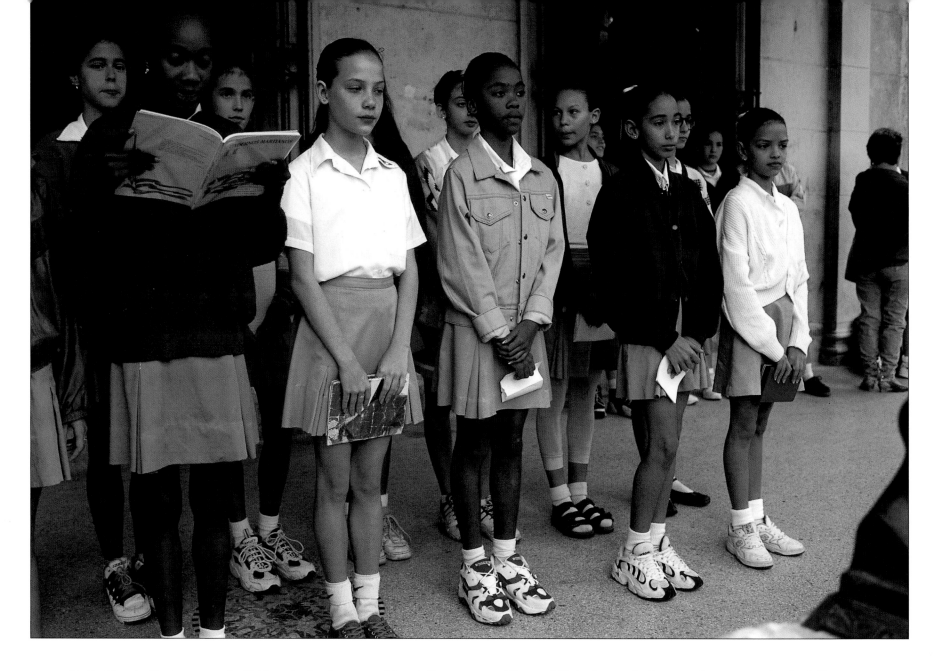

At 7:30, a bell rings, and all the students assemble at the front of the building to salute the flag and sing Cuba's national anthem. A girl reads aloud from a book that describes the sacrifices of Cuba's revolutionary heroes and what those sacrifices have achieved. Today Cuba enjoys one of the highest literacy and lowest child-mortality rates in the world.

Ana goes to her seventh-grade classroom. All the students who attend this school study art, music, theater, or dance in other schools, but here only academic subjects are taught: mathematics, geography, Spanish, and even English. It's not easy for these youngsters to twist their tongues to make the sounds of the English language! But there is no doubt about how seriously and enthusiastically they are involved with their studies. It's not hard to see why. Their teachers are just as enthusiastic—and very dedicated.

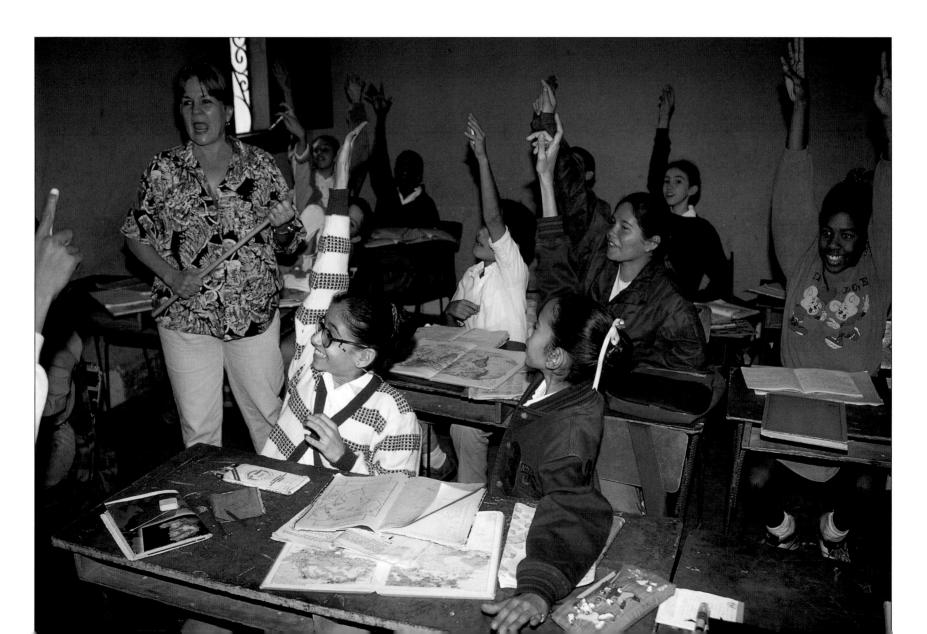

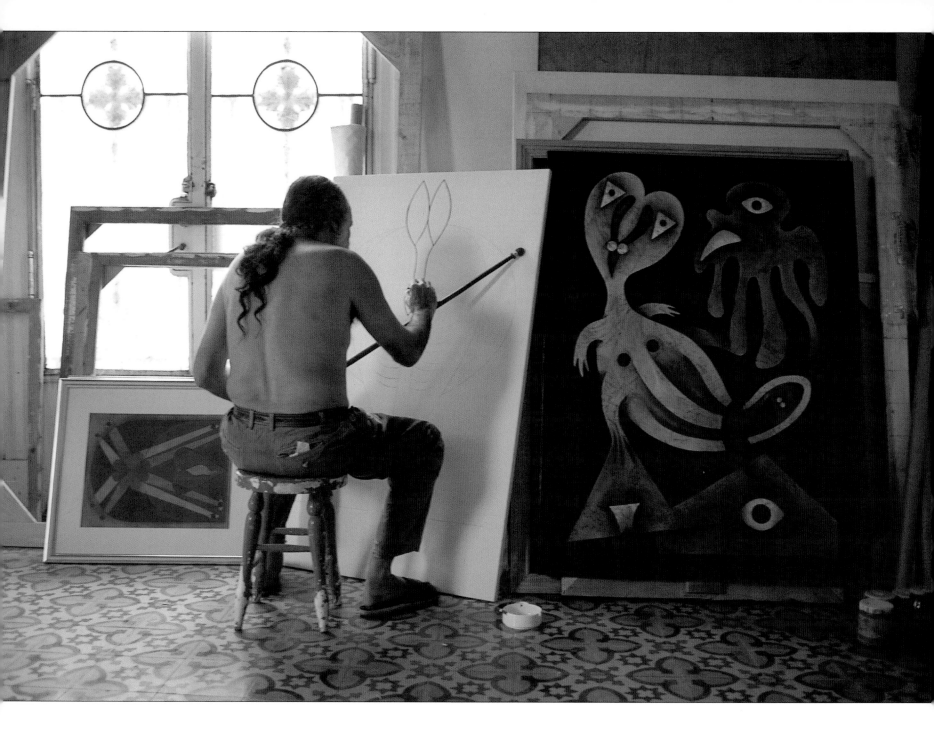

While Ana is in school, both Juan and Alicia are hard at work. Juan's work has been exhibited and sold—not only in Cuba but also in Europe, Latin America, and the United States. Cuba permits its artists to sell and fix their own prices for their work on the free international market. Now Juan's paintings command respectable prices, but that was not always so.

Juan's parents were very poor people who had little education. Juan's great dream was to become an artist. When he was twelve, he dropped out of school and worked cleaning public latrines in order to help support his family. As a young man, he found a job painting billboard advertisements. But he longed to devote all of his time to serious art.

After the revolution, Cuba's new government undertook an intense search throughout the island for people who, regardless of their backgrounds, had the potential and desire to become engineers, teachers, doctors, scientists, and artists. Juan's dream turned into reality when he was admitted as a tuition-free art student at Havana's famed, elite Academia de San Alejandro. Although he is now a successful artist, Juan has never forgotten his humble beginnings, nor has he lost sight of the continuing struggle of many of his countrymen for a better life.

Over the years, Juan's work has evolved through several phases. His current style is strongly influenced by African primitive art. He will name this new painting *La Mascara*—The Mask.

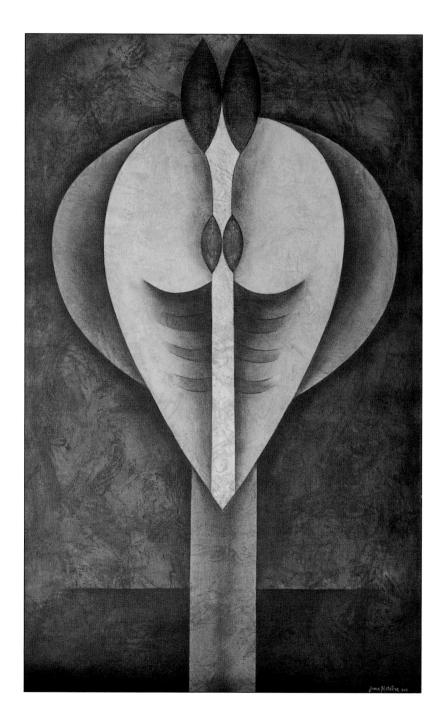

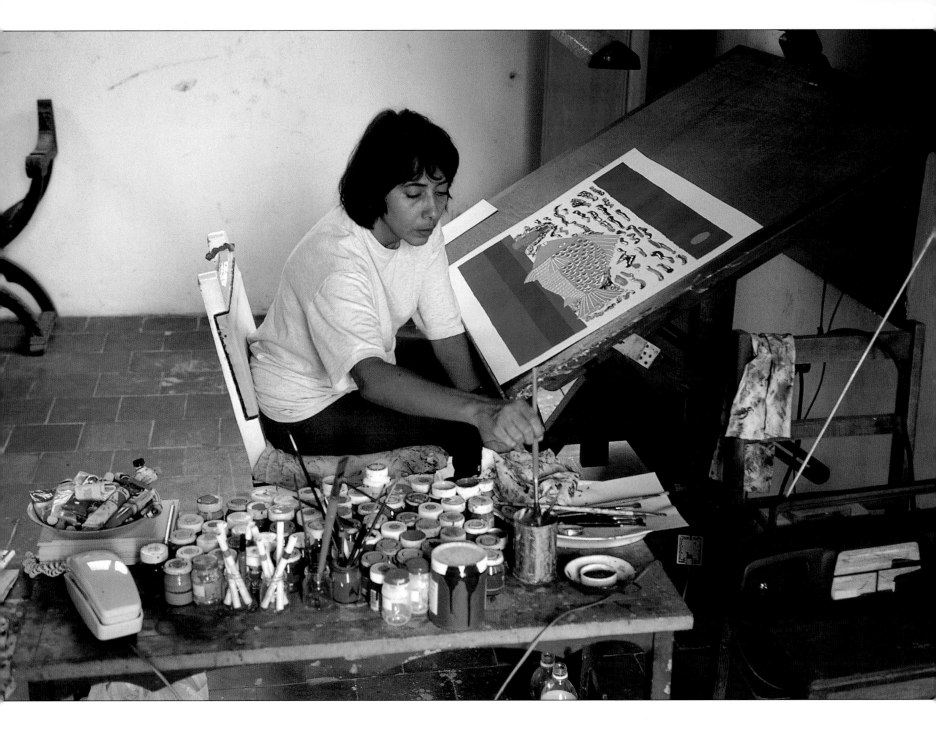

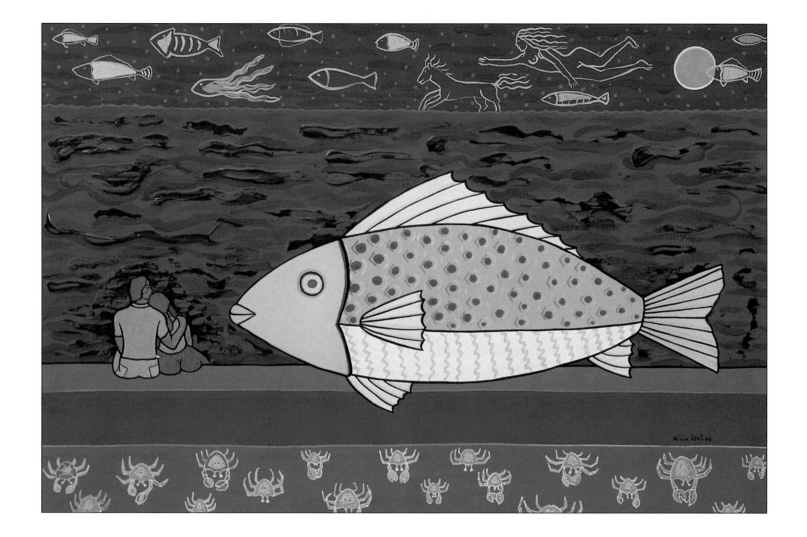

Alicia uses the attic of the house for her studio. Her style of work is totally different from her husband's. She utilizes many elements of Cuba's rich folkloric and romantic traditions. Alicia is now finishing a painting for an exhibition whose theme revolves around Havana's Malecón. This painting portrays two lovers seated on El Malecón's wall, gazing out to sea. While Alicia's works have not yet fetched such high prices as Juan's, they are catching up. In recent years, her paintings have attracted much attention and critical acclaim. Both she and Juan, together with four other Cuban artists, have been invited to contribute four new paintings each for a major exhibition that will travel throughout Japan.

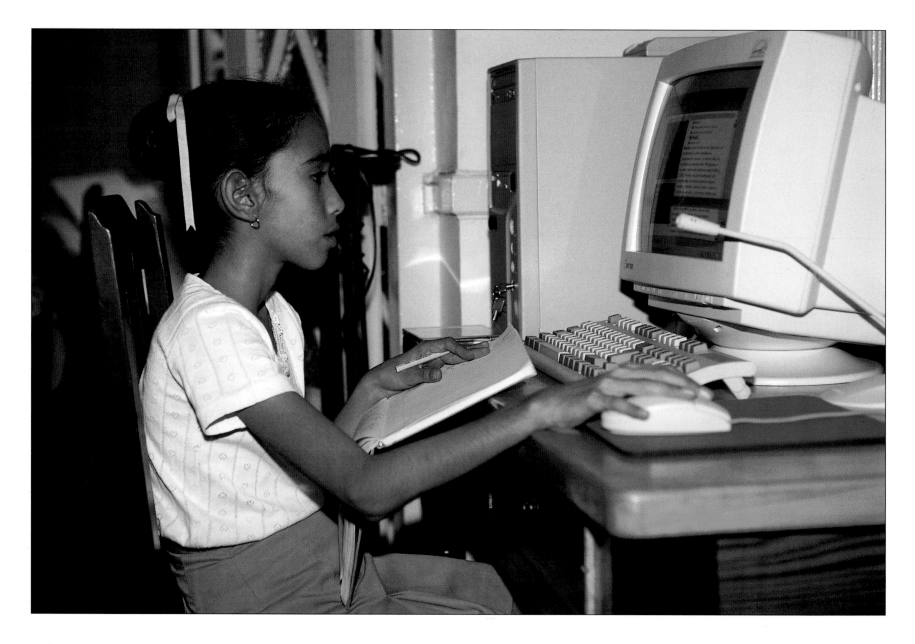

Ana's school classes end at noon, when Juan comes to drive her home for lunch. She has an hour to eat and relax a bit. Instead, she uses some of this time to work out a school problem on her parents' computer. Juan and Alicia bought this equipment to store images of their paintings, plus records of their exhibitions, critical reviews, and sales. When she has time, Ana likes to play computer games, but her school day is far from finished.

At one o'clock, Juan drives her to La Escuela de Alejo Carpentier, a world-famous school sponsored by the Cuban government, which trains children to become ballet dancers. At the entrance, an excited—and nervous—group of first-year students is gathered. This afternoon, these nine-year-olds will present a short demonstration of their skills for Ana's class to evaluate.

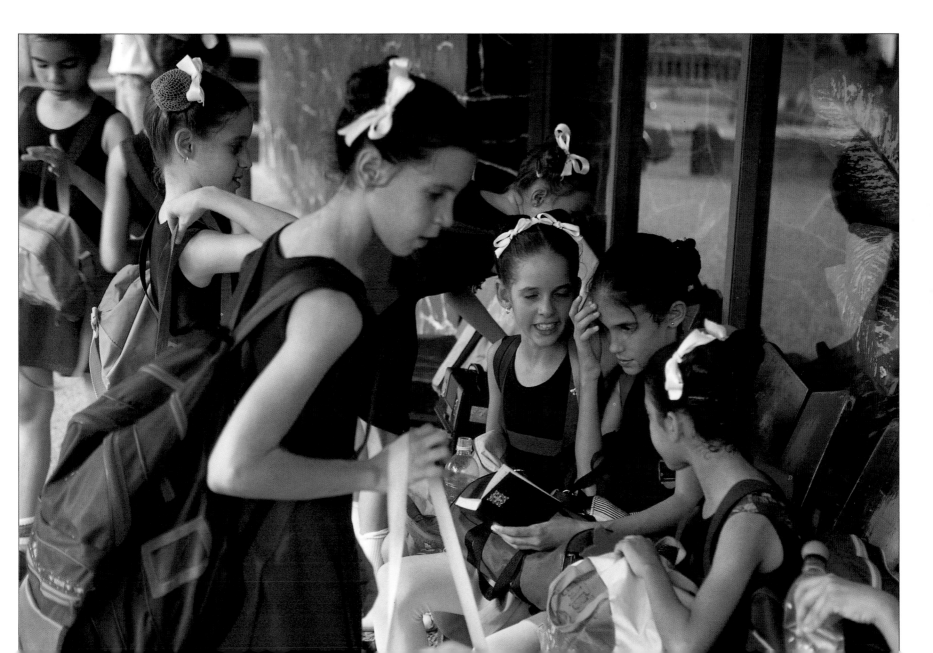

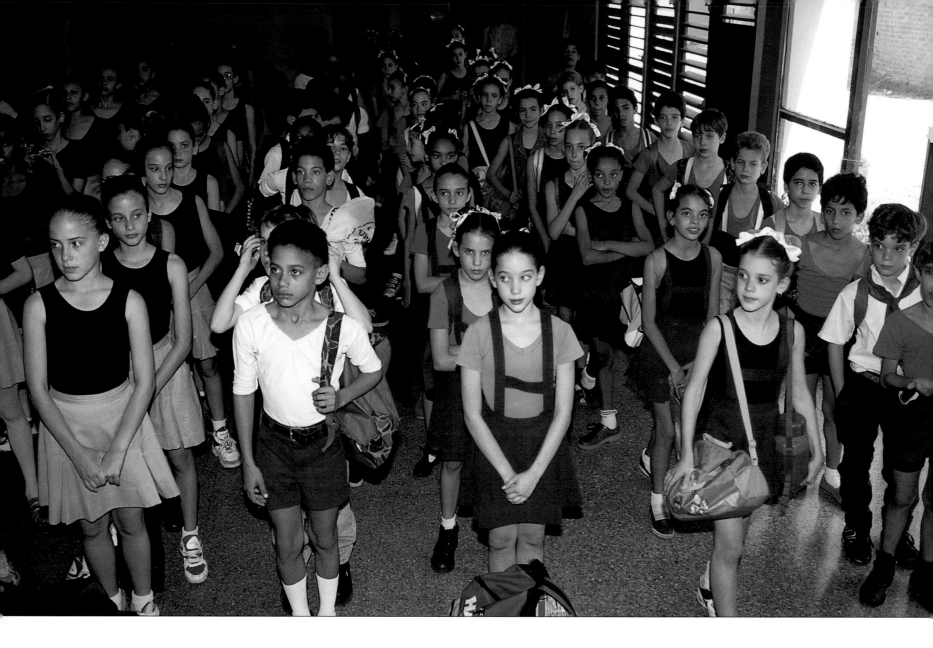

At 1:30, all the students form into their class groups, from first year to fifth. They then file upstairs to their assigned studios and change into leotards.

Children from many countries study here, but only the very best are admitted. There is no tuition, nor is there any guarantee that every student will be allowed to complete the full five-year course of study. Space is limited, and standards are high.

Ana and her third-year classmates watch attentively as the first-year students present their demonstration. Then each of the older students works with one of the younger girls, correcting mistakes they have observed. Some of them may become teachers of ballet in the future.

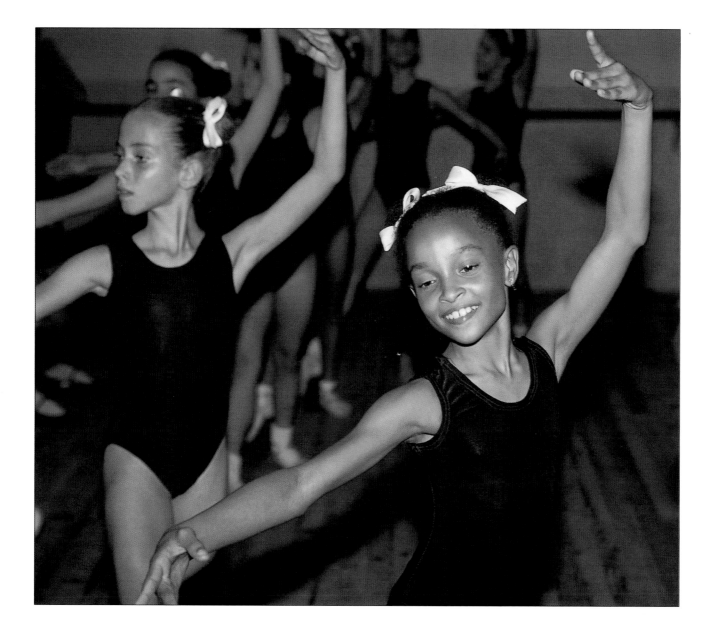

Then it's time for Ana's class to begin its own work. To the accompaniment of a pianist, they start with a series of exercises at the bar that are designed to build muscular coordination, control, and grace. These lay the foundation for ballet technique.

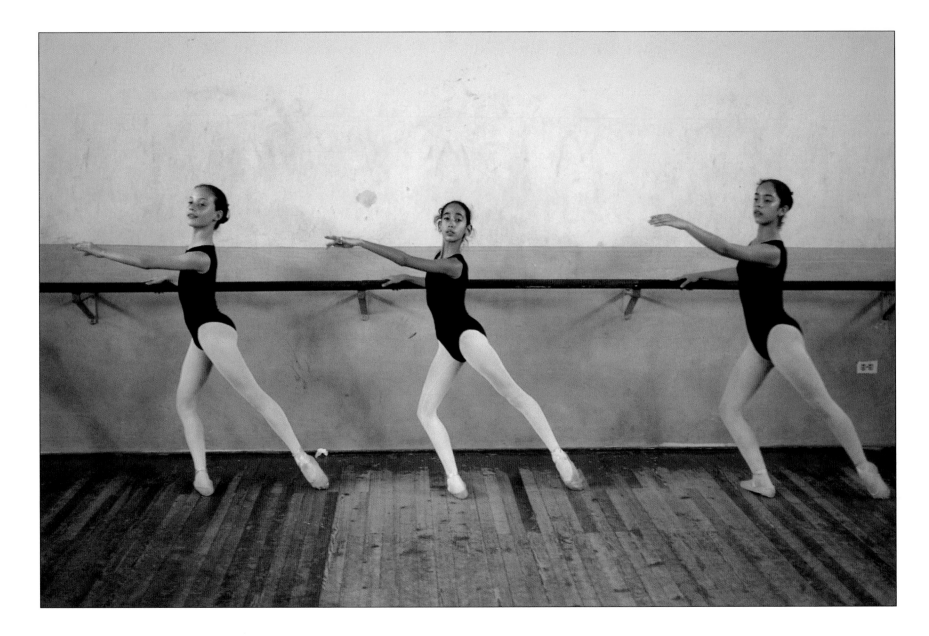

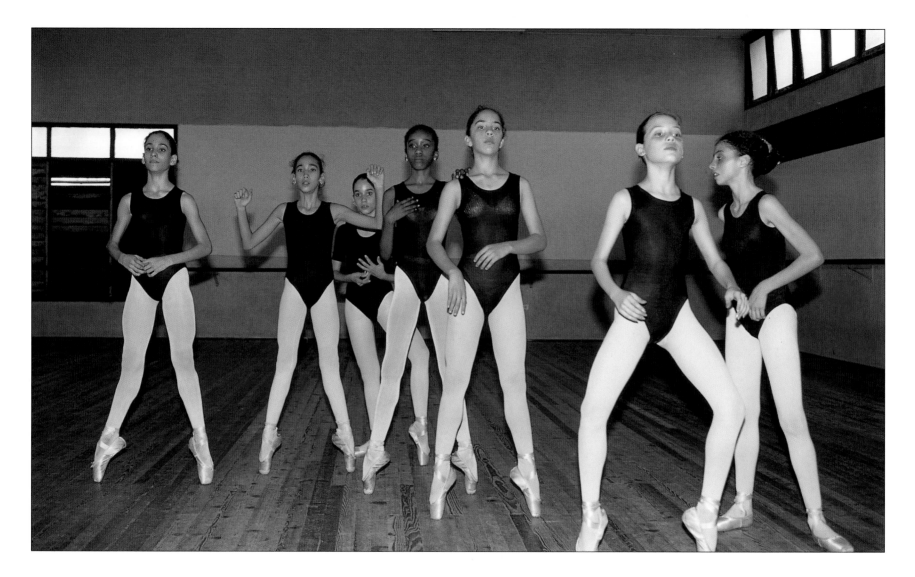

The girls next change into their *pointe* shoes. These are satin shoes that have a hard toe box made of layers of glue and extra fabric, enabling a female dancer to perform on her toes. It takes years of practice to learn how to make dancing *en pointe* look effortless.

To become a ballet dancer requires a life of total dedication and daily sacrifice. A dancer has little time for personal plea-sures, because ballet is the only art form that involves the performer's entire body as an instrument of expression. That instrument requires constant tuning.

Ana began dance instruction at the age of five. Now, al-though she is not as strong as some of the other girls in her class, she has great determination and is holding her own.

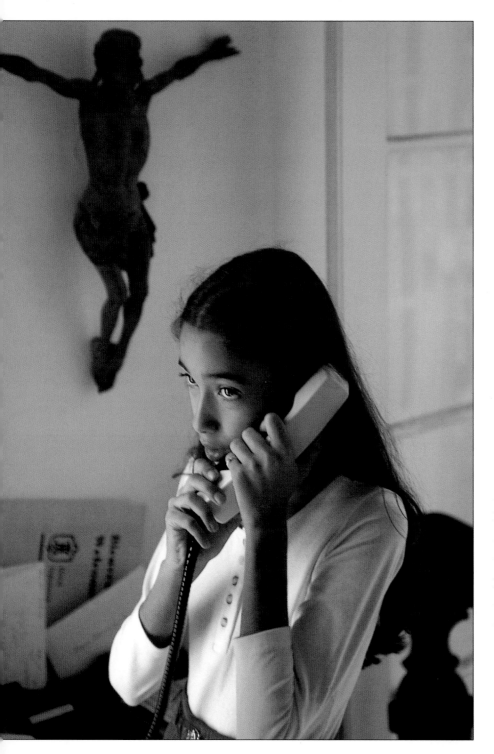

School ends at 6:30 P.M. When Juan brings her home, Ana receives a call from her best friend, Iris Laura García Peña. Iris is going to throw a big party at her house on Saturday night and wants Ana to come. Ana says she'll be there for sure and hangs up the phone. Then she joins her parents for dinner. After dinner, she works on homework assignments. After that, she does her nightly stretching exercises. When she's finished, it's time for bed—about 9:30 P.M. Tomorrow's another school day.

On Saturday evening, when Ana arrives at Iris's house, the party is well under way, and the kids are dancing enthusiastically to loud rock music. But Ana is feeling a bit shy tonight.

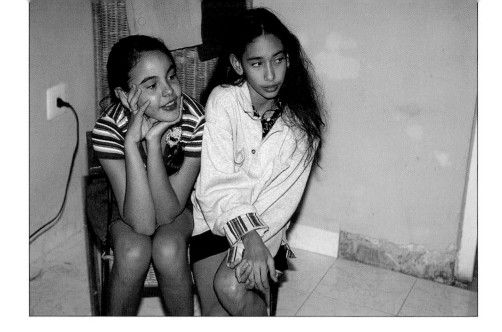

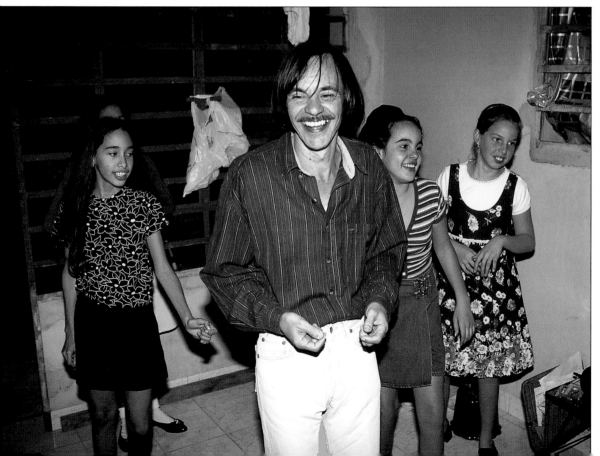

Iris's father, Ernesto, sees Ana, takes her hand, and pulls her to her feet. Tonight everybody's got to join in!

His mission accomplished, Ernesto joins Alicia and Juan in the front room, where they settle into a long conversation about—what else?—art. Ernesto is also an artist and an old friend of Ana's parents.

Before the party starts to break up, Ana makes plans to spend tomorrow with Iris.

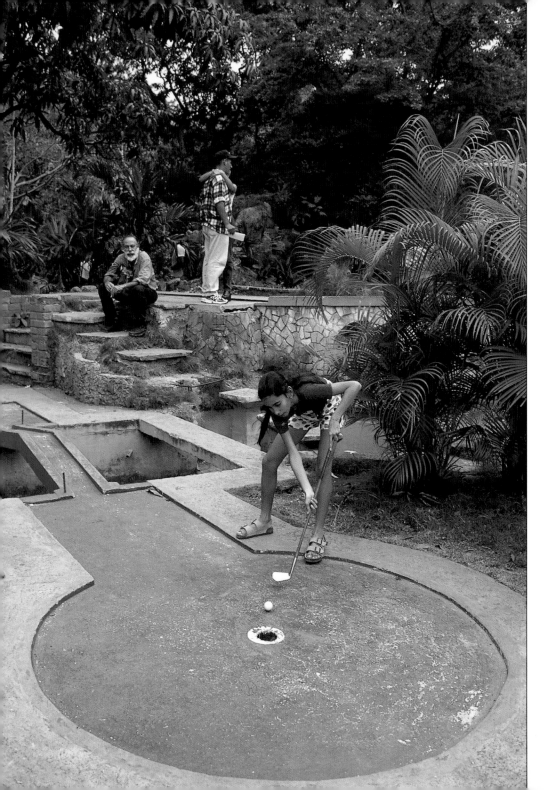

Late the next morning, Juan drives the girls and Alicia to El Parque Almendáriz for a round of miniature golf. Alicia is appointed their official scorekeeper. Through his powers of concentration, Juan winds up with the best score. Next is Alicia, then Iris, and then Ana. Ana is disgusted with herself for doing so poorly! But all the golf clubs are for right-handed people, and she is left-handed.

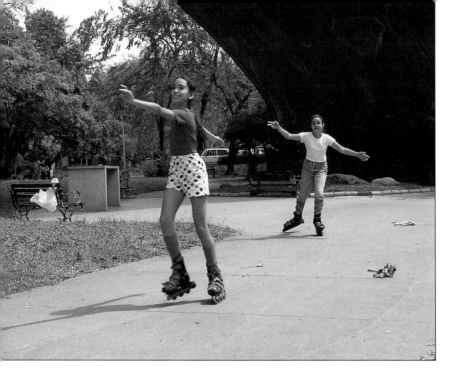

As the winner, Juan treats everyone to lunch at a park café. Iris and Ana each order chocolate ice cream. Then the girls go rollerblading along the walkways, while Alicia and Juan relax on a bench. Back at the house, Ana and Iris practice their ballet exercises before Iris's father comes to drive her home. The weekend is ending all too soon. But it's been great fun.

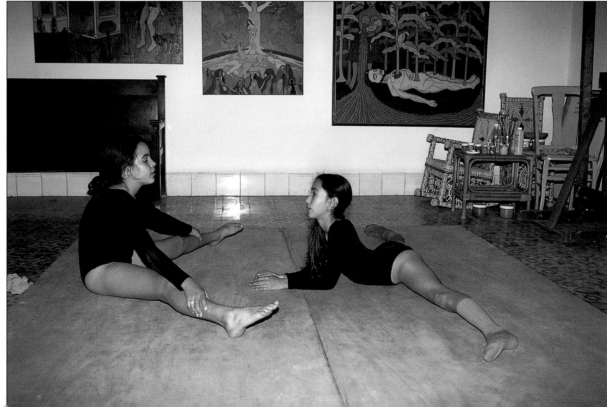

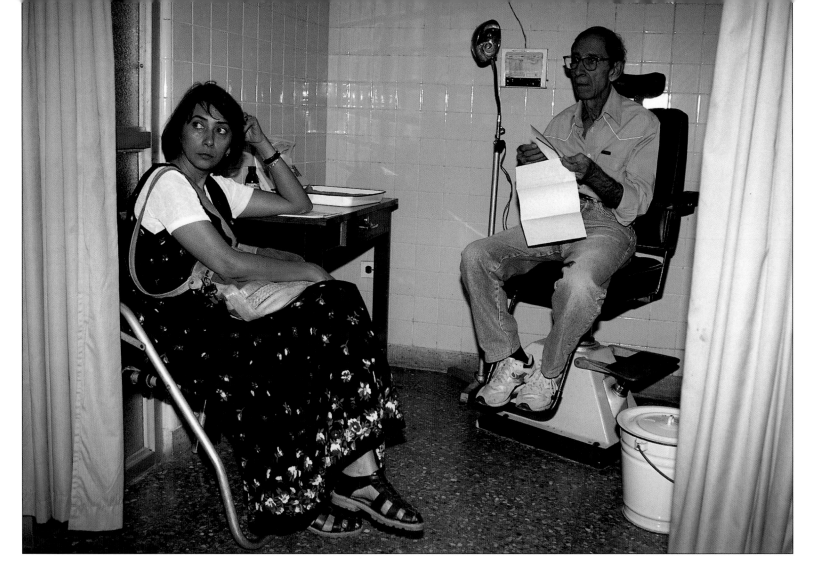

Alicia is very worried about her father. About six months ago, Raul had cataract surgery. Due to the severe shortage of many medicines in Cuba, he was given the only antibiotic available. The surgery was a complete success. But two months later, Raul began to complain of a constant buzzing in one of his ears. This buzzing has driven him into a deep depression.

At the big Amejeiros Hospital in central Havana, Raul and Alicia are shown into a small cubicle and asked to wait for the doctor. Dozens of other people are waiting also.

The quality of medical care in Cuba is outstanding. The only major problem is the lack of critical medication and advanced technical medical equipment needed to diagnose and treat serious illnesses.

After an hour of anxious waiting, a tall woman in a white coat appears and apologizes for the delay. She is Dr. Maria Pérez. Raul and Alicia follow her into her cramped office, where she listens carefully to Raul's problem and makes some notes. She then begins a thorough examination of his eyes, throat, and ears, but can find no physical evidence that might explain this strange buzzing. Perhaps the problem is psychological, she suggests, and gives Alicia the name of a good specialist. But Alicia has her doubts. Her father, a retired army officer, has never been troubled by imagined ailments. Dr. Pérez writes a prescription for a mild sedative and asks to see Raul again in a month. For now, it's the best she can do.

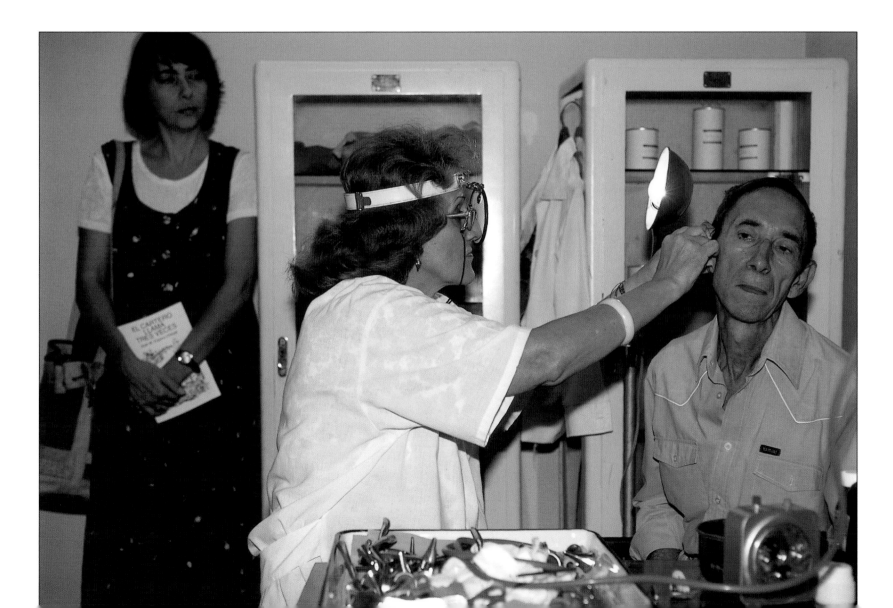

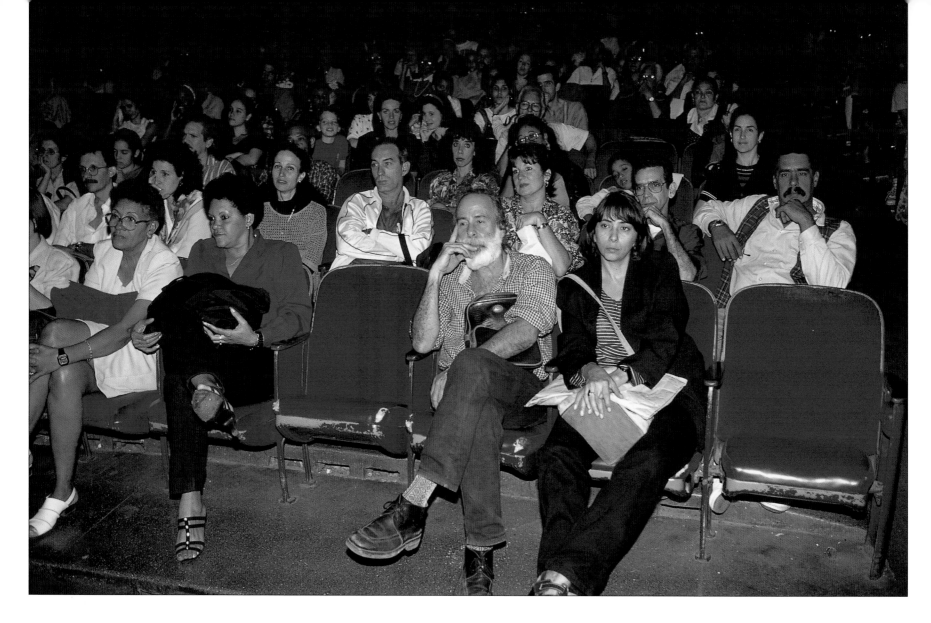

By March, Ana's ballet school has become a place of intense activity. On Sunday morning, the best of the school's fourth- and fifth-year students will present a performance of *The Nutcracker* ballet at Havana's Teatro Nacional! For once, Juan has managed to arrive early and has grabbed seats in the front row for himself and Alicia. Ana is seated in the back with her classmates. The hall is packed with parents, relatives, and friends. Alicia is still distracted by her concern for her father. But, as the curtain rises, she too is carried away into a magical world.

When these dancers graduate from their present school, they will enter the school of El Ballet Nacional de Cuba. Later, the best of the best will join the ranks of that acclaimed ballet company and perform for audiences throughout the world! Ana hopes that time will come for her as well.

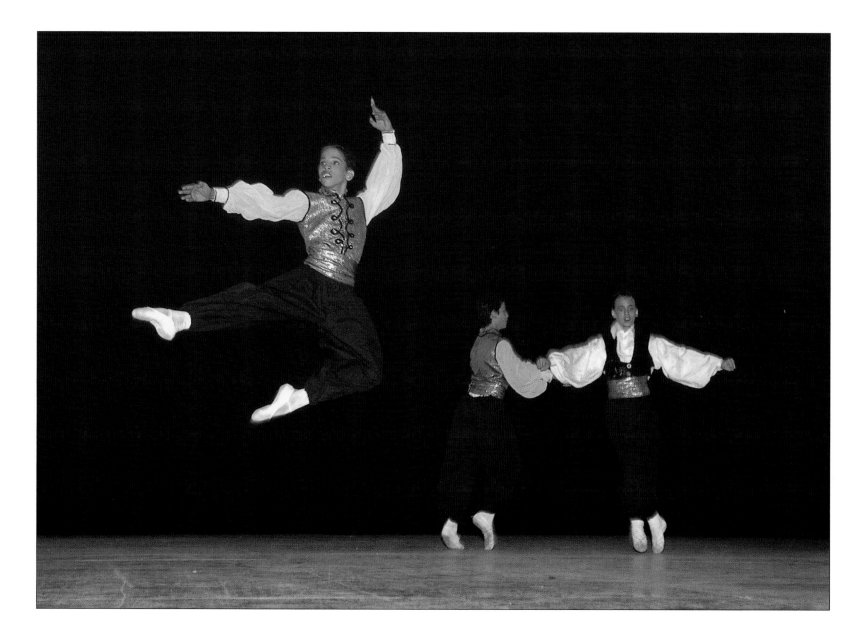

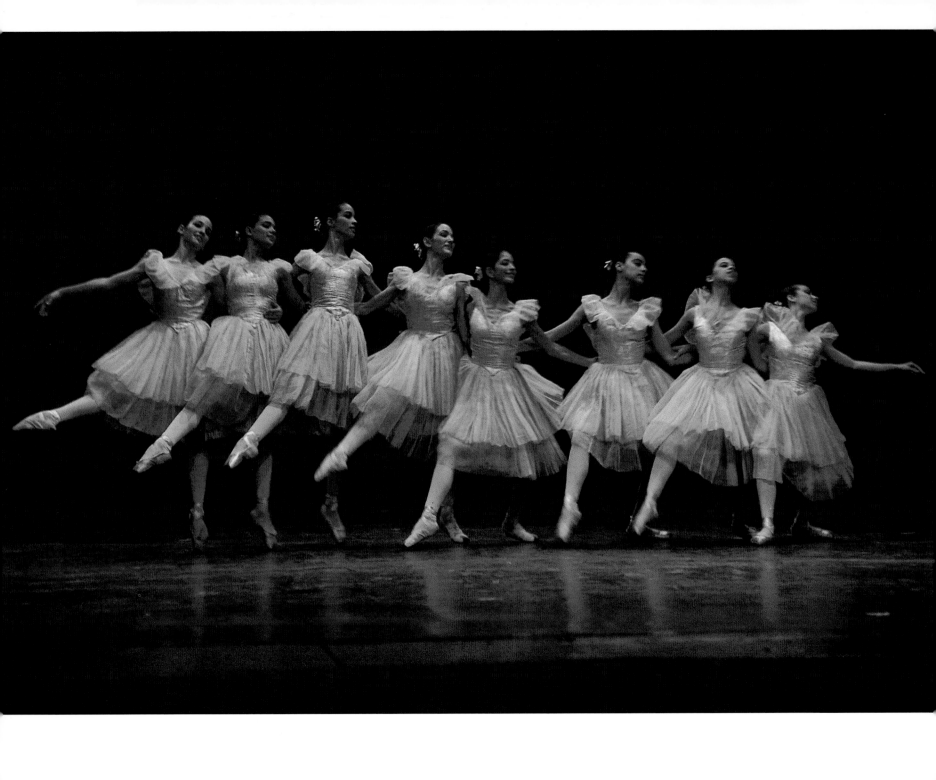

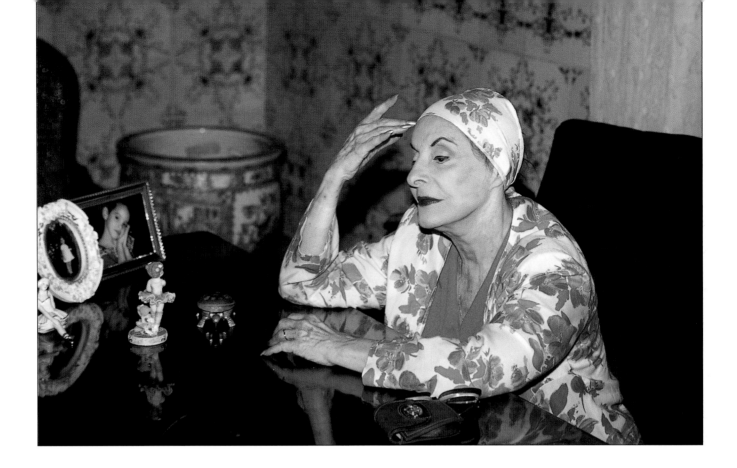

The energy and force behind Cuba's successful ballet achievements are embodied in an extraordinary woman. Alicia Alonso is a living legend in the world of ballet. In 1936, at the age of fourteen, she left her native Havana and came to New York City to further her studies. By 1941, she had won the hearts of audiences and critics as a rising star in the American Ballet Theatre. However, later that same year she had to undergo several eye surgeries to prevent her from becoming blind. Although she was advised to stop dancing, her fierce determination would not allow her to give up the career she loved.

In 1942, following a severe car accident, Alicia Alonso lay immobilized in bed for a year. But she returned to the stage and rose to great triumphs even though she suffered from terrible eyesight throughout her whole career.

Since her late teens, Ms. Alonso had dreamed of establishing a national ballet school and dance company in her native land. After the revolution of 1959, her dream was realized.

Now in her seventies, completely blind and confined to a wheelchair, Alicia Alonso shows up for work each day as the director of her nation's premier ballet company and school. She has set a standard of unique inspiration not only for those who dance but for the entire world.

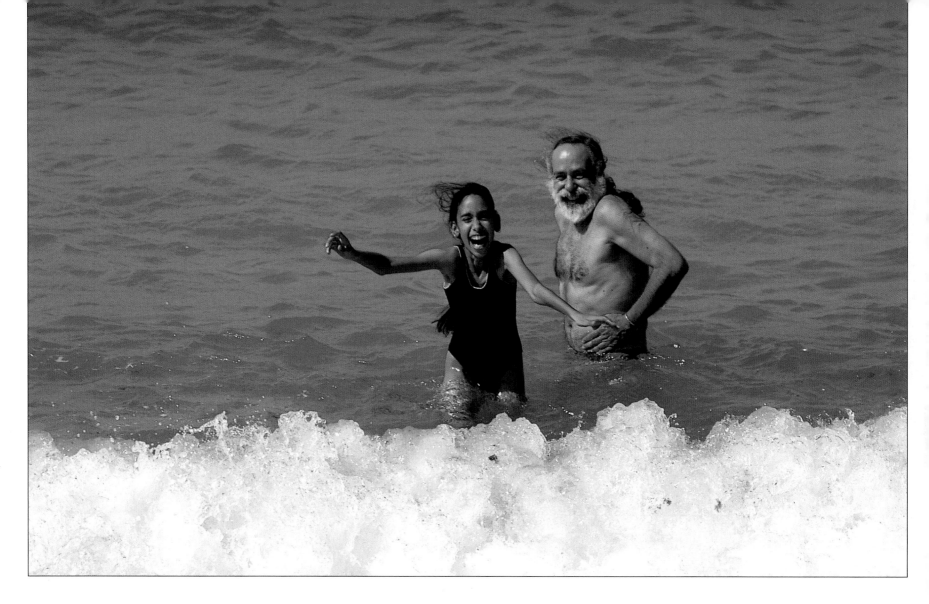

For weeks and weeks, Ana has longed to go to the beach. But as each weekend arrived, the weather refused to cooperate. Either it has rained or the skies have been miserably gloomy. Not today! This morning, the heavens are smiling at her.

It's a ten-mile drive to the closest beach outside Havana.

Ana can't wait to get into the water. She tugs her reluctant father in with her, but Juan refuses to go any deeper. He's got to feel the sand beneath his feet.

In spite of Ana's pleas for her mother to join them, Alicia is too comfortable where she is, lying under the shade of a palm tree.

Late in the afternoon, Ana and her parents take a lazy stroll down the beach. Without warning, Juan grabs Ana and lifts her up while she kicks and screams with laughter. But the moment he puts her down, she mischievously snatches off Alicia's wraparound skirt and runs away with it, laughing even harder!

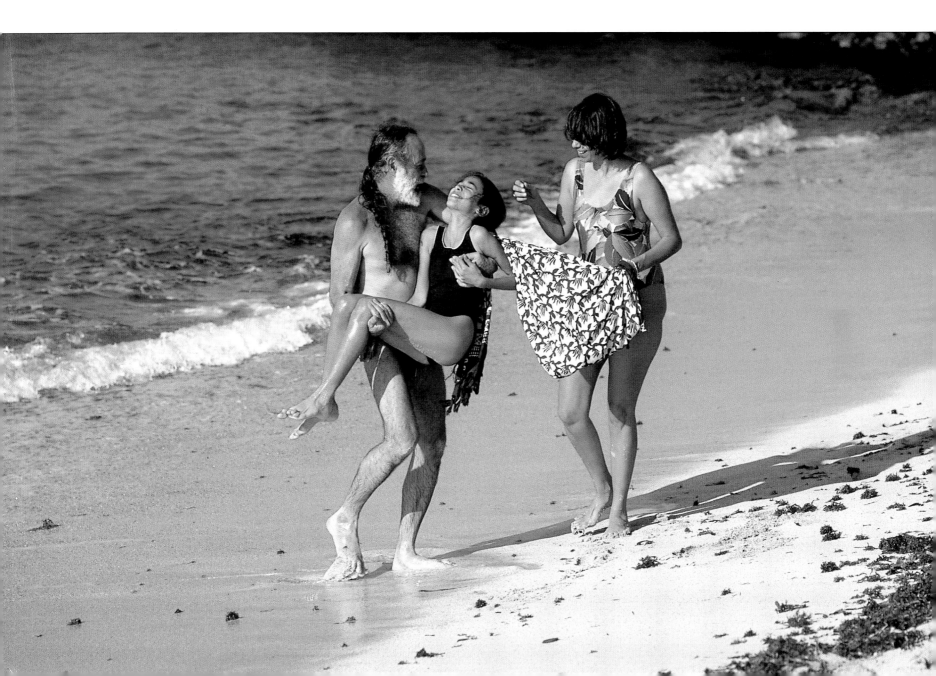

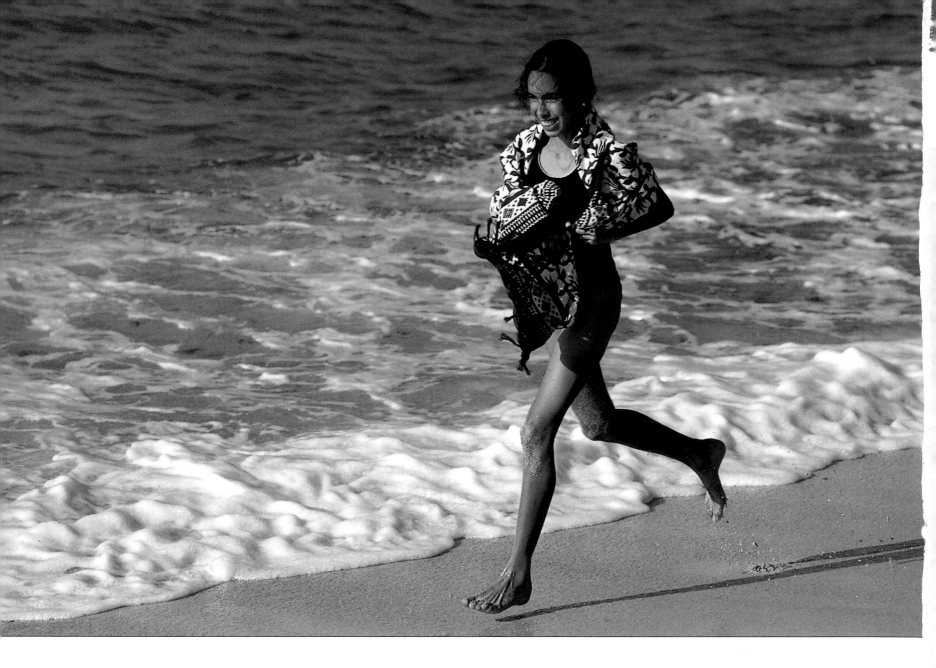

While the future of this troubled island appears clouded
with uncertainty, for Ana the future seems bright with hope
and expectation. ★